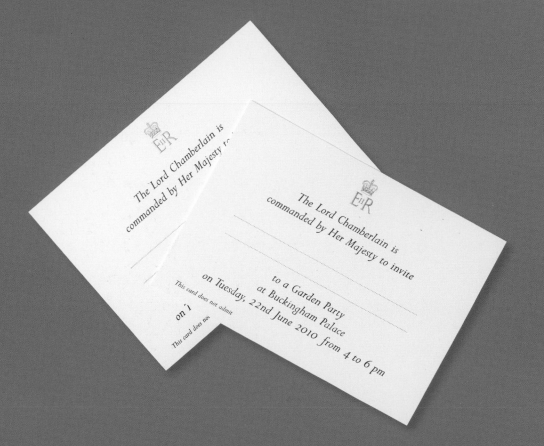

The Lord Chamberlain is
commanded by Her Majesty to invite

...

...

to a Garden Party
at Buckingham Palace
on Tuesday, 22nd June 2010 from 4 to 6 pm

The Lord Chamberlain is
commanded by Her Majesty to

...

This card does not admit

on T

This card does not

THE QUEEN'S YEAR
A SOUVENIR ALBUM

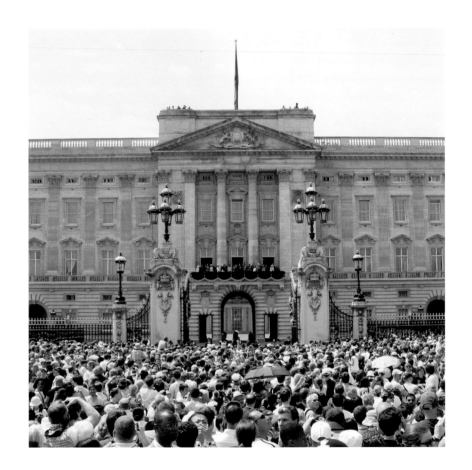

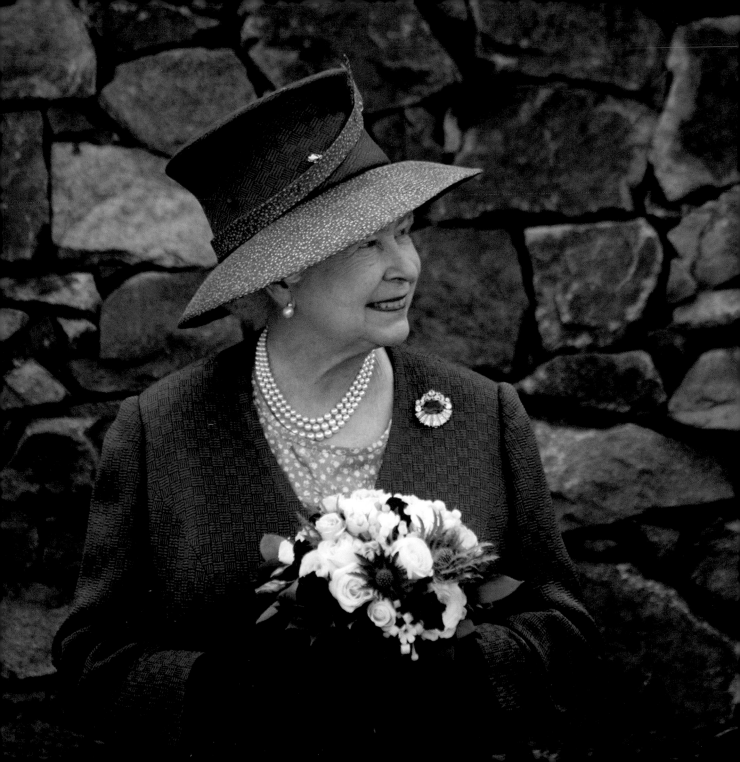

THE QUEEN'S YEAR
A SOUVENIR ALBUM

DAVID OAKEY

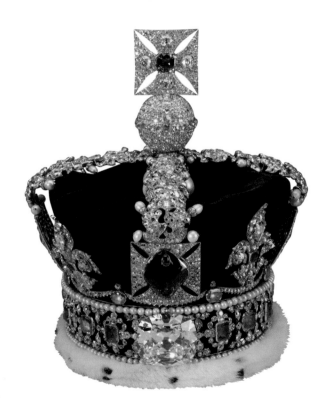

ROYAL COLLECTION PUBLICATIONS

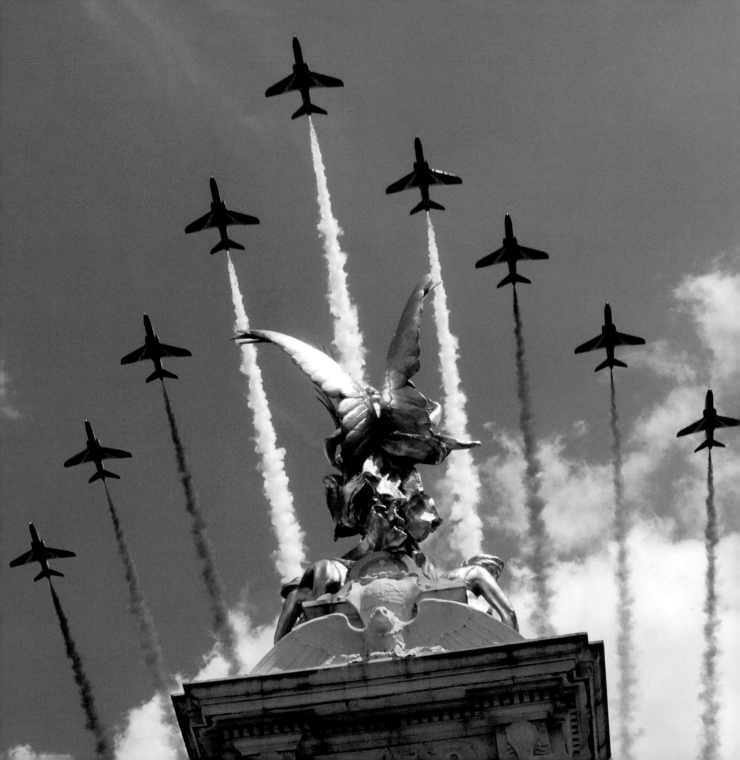

CONTENTS

The events shown in purple occur throughout the year and are not associated with any particular season.

Published by Royal Collection Enterprises Ltd
St James's Palace, London SW1A 1JR

For a complete catalogue of current publications, please write to the address above,
or visit our website at www.royalcollection.org.uk

ISBN 978-1-905686-34-6

British Library Cataloguing in Publication Data:
A catalogue record for this book is available from the British Library.

Designed by Peter Drew of Phrogg Design
Typeset in Garamond
Production by Debbie Wayment
Printed on Gardamatt 150gsm
Colour reproduction by Altaimage, London
Printed and bound in Italy by Printer Trento

Mixed Sources
Product group from well-managed
forests and other controlled sources
www.fsc.org Cert no. CQ-COC-000012
© 1996 Forest Stewardship Council

SEASON
CALENDAR
2010

The passage of a year in the life of every nation is marked in many different ways – some which stem from ancient tradition – such as religious festivals – and others which take root around great sporting occasions. This book sets out to show how in the United Kingdom and Commonwealth, the Sovereign's annual calendar defines the nation's calendar, with its moments of high ceremony such as the Royal Maundy at Easter, Trooping the Colour in June, the State Opening of Parliament and the Service of Remembrance in the autumn and more informal occasions, such as Garden Parties and Royal Ascot. During The Queen's reign each month of the year has come to have its own cycle of events, and each royal residence its own season or month of heightened activity. The aim has always been to ensure that Her Majesty's duties as Head of State and Head of Nation are conducted in ways that are visible and relevant to the lives of as many people as possible.

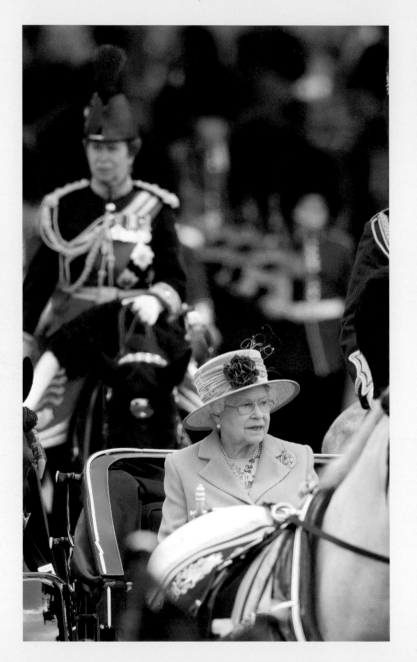

Visibility has always been a prime objective of the British monarch. The first Queen Elizabeth was famed for her royal tours around the country – opportunities for the people to see their sovereign in person. A calendar of royal feast days and solemnities acted in much the same way. Some of these occasions have faded with the passing of centuries, but many have remained an integral part of national life.

The Queen spends particular parts of the year at her official residences – Buckingham Palace, Windsor Castle and the Palace of Holyroodhouse; and at her private residences – Sandringham House and Balmoral Castle. During each of these periods the senior members of the Royal Household, together with those who provide close support to Her Majesty (including chefs, housekeepers, clerical and administrative staff) move with her.

In addition, throughout the year The Queen travels widely, both at home and abroad. Nearly every day the official red boxes continue to arrive, even when Her Majesty is away from London. These contain governmental papers and briefings, along with documents relating to the running of the Royal Household.

The Royal Household is divided into five departments, each one overseen by a senior official. The Lord Chamberlain is head of the Royal Household. The Lord Chamberlain's department is responsible for ceremonial, constitutional and ecclesiastical matters. The Queen's programme, correspondence and interaction with the government are managed by the Private Secretary. The department headed by the Master of the Household oversees official and private royal entertaining, accommodation and the day-to-day running of the Household; while the

Keeper of the Privy Purse and his staff oversee The Queen's finances. Finally, the Royal Collection department is charged with the care and presentation of the works of art in the royal residences.

The Queen's year involves a regular programme of events, including twenty-five investitures, at which civil and military achievement is recognised, eight meetings of the Privy Council, twenty-four presentations of credentials by high commissioners and ambassadors, and many audiences with senior figures in public life.

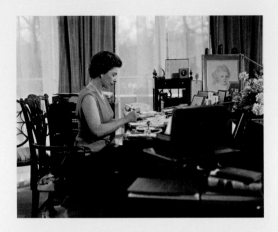

Her Majesty will also give at least twenty receptions, and numerous luncheons and dinners to a wide range of people from all walks of life.

During the year The Queen will sit for portraits commissioned by public bodies and institutions. She will usually represent the United Kingdom abroad on two state visits, and receive two foreign Heads of State at Buckingham Palace or Windsor Castle. Her Majesty will also visit various carefully selected locations around the country enabling local people to see and, where possible, meet her.

These regular events include a sequence of colourful and symbolic occasions that have become closely associated with specific times of the year and perfectly illustrate the different aspects of The Queen's role. In the spring there is a Commonwealth Day, which Her Majesty attends as Head of the Commonwealth, and the Royal Maundy Service in which she participates as Supreme Governor of the Church of England. Each summer at Trooping the Colour on Her Majesty's official birthday, The Queen presides as Colonel-in-Chief of all her Household Regiments, and on Garter Day she appears as Sovereign of the Order of the Garter – the highest order of chivalry in England. In the autumn The Queen leads the nation in the act of remembrance at the Cenotaph in Whitehall, and inaugurates a new legislative year at the State Opening of Parliament.

At Christmas Her Majesty's annual message is broadcast to millions across the United Kingdom and Commonwealth.

Her Majesty performs an important role as Head of Nation, providing a focus for national identity, unity and pride. Each year is a journey of its own, enabling The Queen to remain well informed about the UK and its people. Most importantly, the annual programme of activities also makes it possible for people to see or meet The Queen for the first time. At the start of the second decade of the twenty-first century, and at the close of the sixth decade of Her Majesty's reign, The Queen's year remains as busy as ever.

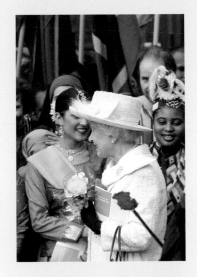
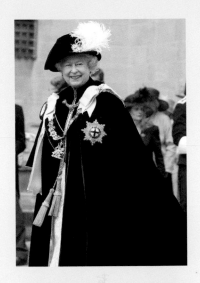

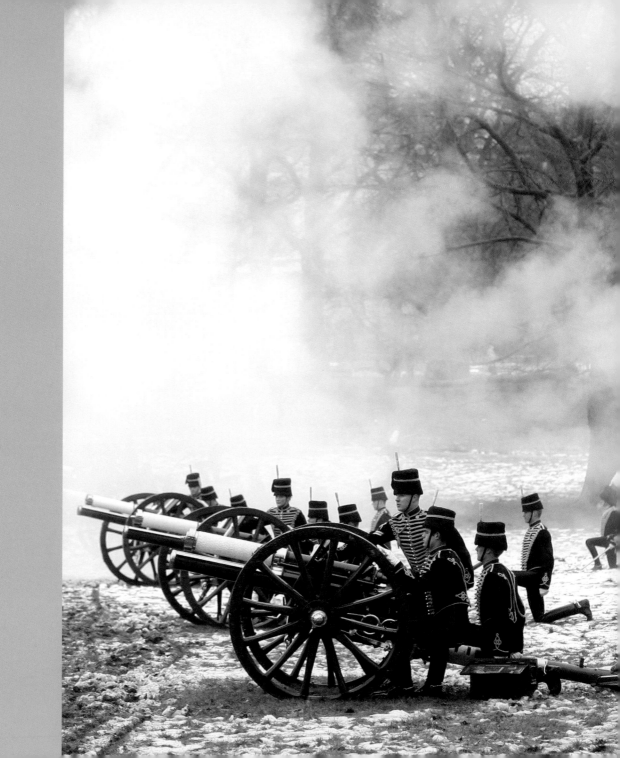

A NEW YEAR

The Queen's year begins at Sandringham House, Her Majesty's private residence in Norfolk. Even in the years when the Royal Family have celebrated Christmas at Windsor Castle, The Queen has always been at Sandringham in time for New Year. January is a quiet time with only a few local visits and engagements, including the Annual General Meeting of the Sandringham branch of the Women's Institute at which The Queen, as president, delivers a speech.

Accession Day, the anniversary of The Queen's accession to the throne in 1952, falls on 6 February. Royal salutes are fired across the United Kingdom (left). This is often the last full day that The Queen spends at Sandringham before she returns to the capital. Thus while the day commemorates the beginning of a reign, it also marks the beginning of a new royal year. Her Majesty's arrival in London sees the start of The Queen's annual routine of investitures, audiences and engagements.

SPRING

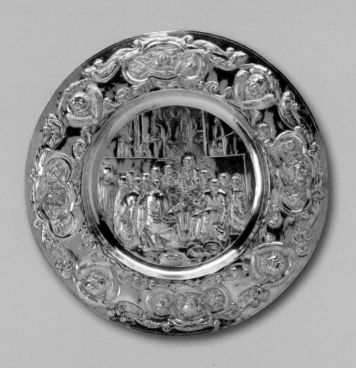

Commonwealth Day

Commonwealth Day is celebrated throughout the Commonwealth of Nations on the second Monday of March. It is marked in the United Kingdom by the colourful Observance for Commonwealth Day held in Westminster Abbey. This is an inter-faith service that embraces the diversity and vitality of the Commonwealth, with dignitaries, high commissioners, religious leaders, citizens and school children from all of the fifty-four member states in attendance. The ceremony begins with a procession of flag bearers, each representing a member state.

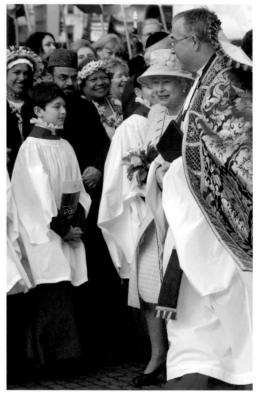

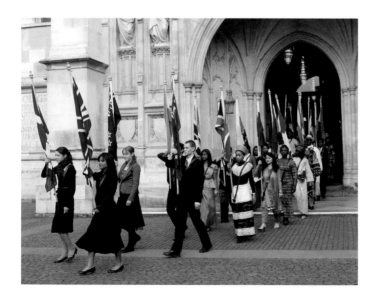

It features a lively assortment of musical performances, with readings from representations of the Commonwealth's various faiths, and speeches from The Queen and from the Commonwealth Secretary-General.

The service at Westminster Abbey is followed by a reception given by the Commonwealth Secretary-General at the headquarters of the Commonwealth Secretariat, Marlborough House. The Queen is shown here meeting some of the high commissioners' wives at the reception in 1972.

Commonwealth Day is also marked by the sending of a message from The Queen to the people of the Commonwealth. Like the Christmas broadcast, it is an opportunity for Her Majesty to voice her own views, concerns, and good wishes, continuing a tradition begun by her father, King George VI.

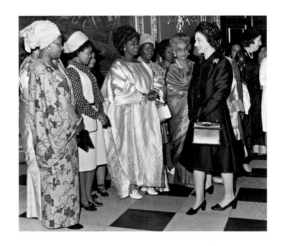

Commonwealth Day

Each year Commonwealth Day has a theme. In 2010 it was Science, Technology and Society. The theme may be accompanied by a promotional poster, which is sent out to schools and colleges. Events based on the same subject take place throughout the Commonwealth.

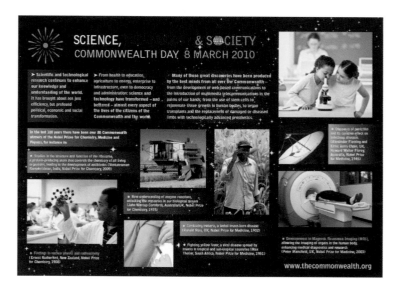

Commonwealth Day Themes:

1994 The Commonwealth Games

1995 Tolerance

1996 Working in Partnership

1997 Communications

1998 Sport

1999 Music

2000 The Communications Challenge

2001 A New Generation

2002 Celebrating Diversity

2003 Partners in Development

2004 Building a Commonwealth of Freedom

2005 Education – Creating Opportunity, Realising Potential

2006 Health and Vitality

2007 Respecting Difference, Promoting Understanding

2008 The Environment – Our Future

2009 The Commonwealth at 60 – Serving a New Generation

2010 Science, Technology and Society

Every four years since 1958, the Commonwealth Games Queen's Baton Relay has been started by The Queen. This usually happens on Commonwealth Day. The 2006 relay of the Melbourne Games baton was the most extensive yet, travelling for one year and a day and visiting every nation of the Commonwealth. The baton for the 2010 Games will go on an even longer relay, travelling through the entire Commonwealth, then all twenty-eight Indian states, finally arriving in Delhi in time for the opening ceremony of the Commonwealth Games in October.

Following the launch of the relay, the next time The Queen will see the baton is usually at the opening ceremony of the Games, as seen below when it was presented by David Beckham and Kirsty Howard in 2002.

To commemorate these Games, Her Majesty was presented with a replica of the baton used during the relay (top left). Another replica baton was presented following the 1998 Games in Kuala Lumpur (top right).

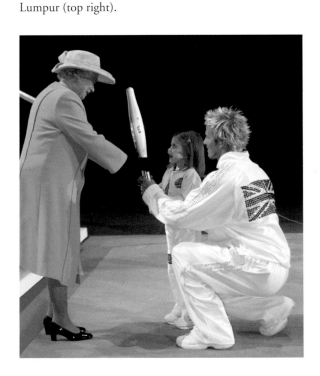

Commonwealth Day

Commonwealth Day has been an occasion for important commemorations and unveilings related to the Commonwealth. In 2002 this portrait of The Queen by the artist Chinwe Chukwuogo-Roy was unveiled to mark Her Majesty's Golden Jubilee. It shows Her Majesty standing before a composite scene of some of the Commonwealth's most famous landmarks (including the Palace of Westminster, the Taj Mahal and the Sydney Opera House), and now hangs in Marlborough House.

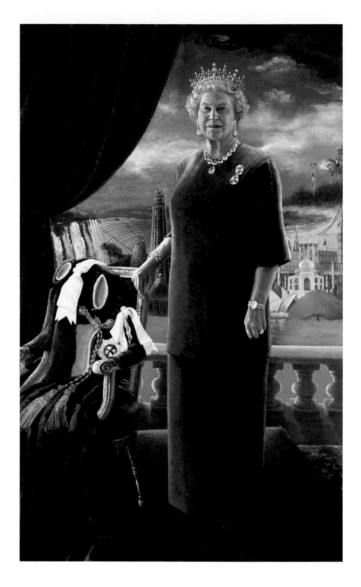

These colourful stamps were issued on Commonwealth Day 1983 by the Royal Mail, marking thirty years since The Queen was proclaimed Head of the Commonwealth. They illustrate the contrasting terrains that can be found across the Commonwealth.

Commonwealth Day

The Queen's position as Head of the Commonwealth is symbolised by the Commonwealth Mace, presented to Her Majesty in 1992 to mark the fortieth anniversary of her accession to the throne. It bears the Royal Coat of Arms, the Commonwealth symbol, and the enamelled flags of all the Commonwealth nations. It is carried in procession during the Commonwealth Day service.

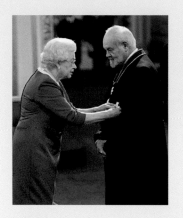 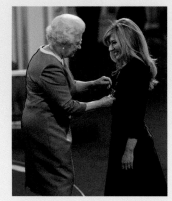 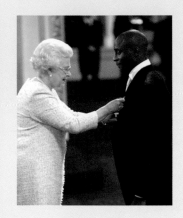

The award of an honour from The Queen is a moment of great pride for the recipient. Awards may be presented for service to the nation, in commerce, industry, education, a charity or good cause. An award of this kind expresses gratitude and recognition for a contribution to national life, great or small; no area of accomplishment is precluded. Wherever possible, an award bestowed in The Queen's name is presented either by her or by a senior member of the Royal Family. Every year twenty-five investitures take place, each with about 300 people attending. The Queen now undertakes around half of these, with the remainder carried out by the Prince of Wales or the Princess Royal.

At each investiture approximately 100 awards are presented. The insignia are carefully laid out in the correct order beforehand.

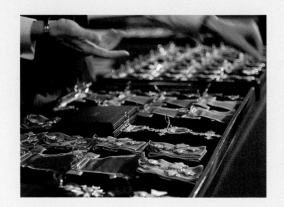

Investitures usually take place at Buckingham Palace, and occasionally at Windsor Castle. An investiture is also held at the Palace of Holyroodhouse during The Queen's annual visit in June or July. The photograph below shows The Queen leaving an investiture escorted by the Lord Chamberlain and, respecting a tradition begun by Queen Victoria in 1876, a Gurkha orderly officer.

The Central Chancery of the Orders of Knighthood, a specialist department of the Royal Household based in St James's Palace, is responsible for organising each investiture. They send out the invitations, arrange the insignia in preparation for distribution at the ceremony, and maintain all records relating to the various orders.

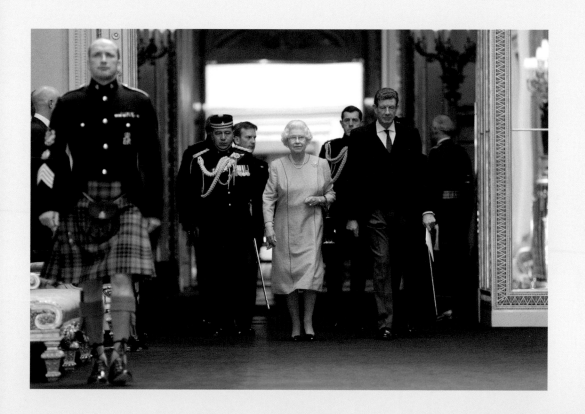

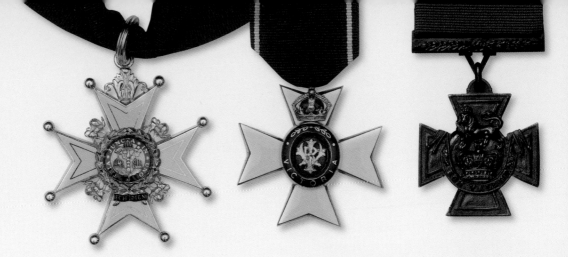

Twice a year, on The Queen's official birthday in June and on New Year's Day, the names of those who will receive awards are announced. The names will have been agreed from lists sent in by The Queen's Lord-Lieutenants across the United Kingdom, government departments, local authorities, and educational and industrial organisations. The most numerous appointments each year are to the Order of the British Empire, in either its civil or military divisions. Appointments to the Order of the Bath (above left) include senior civil servants and officers in the armed forces. Those to the Order of St Michael and St George are generally for service to the Crown overseas. Some awards are the personal gift of The Queen. These include appointments to the most distinguished Orders of the Garter and Thistle, the Order of Merit, and the Royal Victorian Order (above centre) – the latter for personal service to Her Majesty.

The highest military award, open to every rank in the armed forces, is the Victoria Cross (above right). As inscribed on the decoration itself, it is awarded 'For Valour' in the face of the enemy. Only 1,300 VCs have been presented since the award was instituted by Queen Victoria in 1856. The most recent being in 2005.

At an investiture the Lord Chamberlain announces each name with a brief citation of the reason for the award. For those receiving a knighthood, a stool is set out, enabling the recipient to kneel to be dubbed with a sword on both shoulders by The Queen. The sword used by The Queen at investitures (right) belonged to her father, King George VI.

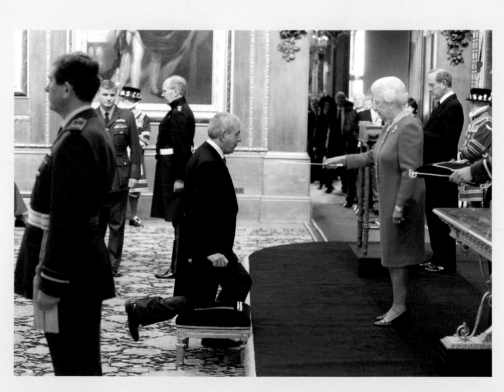

The Royal

Maundy Service

The Royal Maundy Service is held on Maundy Thursday, the Thursday before Easter and is attended by The Queen as Supreme Governor of the Church of England. It commemorates the *mandatum* (the Latin word for 'command') given by Jesus to his disciples at the Last Supper, directing them to love one another. He followed this by tying a towel around his waist, before kneeling and washing each of their feet in turn. The ceremony of Royal Maundy has been associated with the British monarchy since at least the thirteenth century.

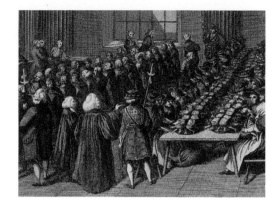

In the Tudor and Stuart periods the sovereign was closely involved in the service, washing the feet of paupers and distributing food and money. From the mid-seventeenth century no reigning sovereign attended the Maundy Service for nearly two hundred years. These illustrations show the ceremony taking place in the Chapel Royal at Whitehall during the reign of George III in the late eighteenth century.

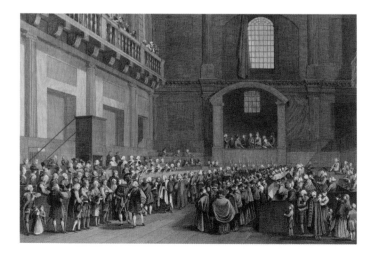

The Queen's grandfather, King George V, revived the tradition of direct royal participation in the service, which now has an important place in the royal calendar. Previously held only in London, since early in The Queen's reign the service has been held in a different cathedral or abbey in the United Kingdom each year.

The tradition of washing feet is now signified by the Maundy towels worn by those attending The Queen (right).

In the modern ceremony the recipients of Maundy gifts are chosen for their service to the community or church. Because the number of male and female recipients each correspond to the sovereign's age, the Maundy Service is now considerably longer and larger than it was at the beginning of the reign.

**The Royal
Maundy Service**

Today no food is distributed, but Maundy coins produced in the Royal Mint are handed out in red and white purses, the design of which has remained the same since the Tudor period. The white purse contains the silver Maundy coins (1, 2, 3 and 4 penny pieces below), while the red purse holds £5.50 in legal tender. The Maundy coins bear the profile of The Queen designed in the first full year of her reign (1953) by the sculptor Mary Gillick. A collection of Maundy coins (left) dating from the reign of George III is preserved in the Royal Library at Windsor Castle.

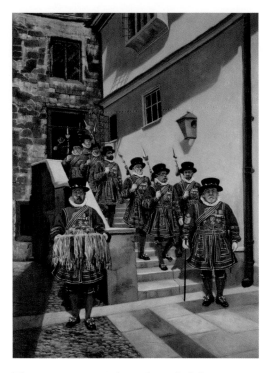

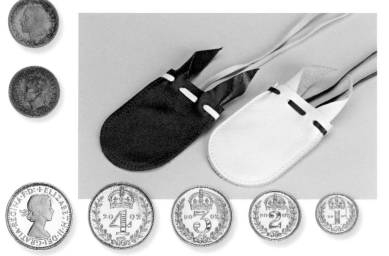

The purses are carried on silver gilt dishes by The Queen's Ceremonial Bodyguard, the Yeomen of the Guard, in full dress uniform. In this painting of the Yeomen before the service at Westminster Abbey in 1910, the Yeoman on the left holds a dish laden with the purses ready for distribution.

The two dishes used in the Maundy
Service are especially fine examples
of workmanship in silver gilt and
date from 1661. One is decorated
with freshwater, the other with
saltwater fish.

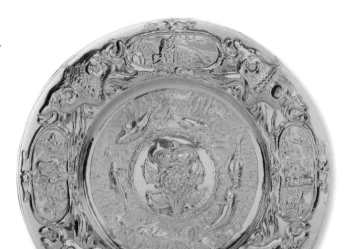

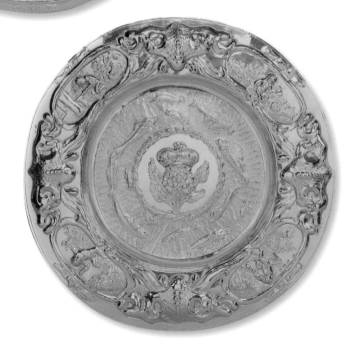

The Royal Maundy Service

One of the most senior clergymen involved in the Royal Maundy Service is the Lord High Almoner, whose office dates from 1103. In the past, it was his role to distribute alms to the poor on behalf of the sovereign, but now his duties are confined to the organisation of the Royal Maundy Service and the promotion of its historical and religious importance. The Lord High Almoner is recognisable by his distinctive cope, decorated with his emblem – a ship. The position is currently held by the Bishop of Manchester.

The procession into the church is led by a full-time member of The Queen's clerical staff, the Serjeant of the Vestry, bearing a special verge (above) which was designed in 2007 to commemorate The Queen's and the Duke of Edinburgh's diamond wedding anniversary.

These wands are used in the service to help direct The Queen to the recipients of Maundy money. They are held by wandsmen, whose families have, in many cases, fulfilled this role for generations.

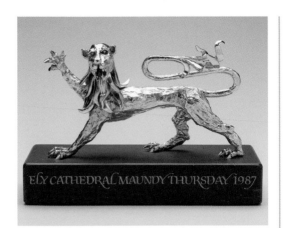

The movement of the ceremony around the
United Kingdom has re-invigorated the service.
Its celebration in a particular town or city creates
great interest, and is often commemorated by
a civic gift to The Queen. These have included a
Wakeman's horn (far right) from Ripon, a silver
lion (above) from Ely, a cow bell
(right) from Armagh
and a tin ingot
(overleaf) from Truro.

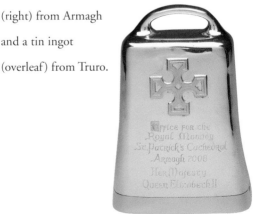

The Maundy Service has been celebrated in the
following locations during the current reign:

1952	Westminster Abbey
1953	St Paul's Cathedral
1954	Westminster Abbey
1955	Southwark Cathedral
1956	Westminster Abbey
	(Lord High Almoner officiated)
1957	St Albans Abbey
1958	Westminster Abbey
1959	St George's Chapel, Windsor
1960	Westminster Abbey (Queen Elizabeth
	The Queen Mother officiated)
1961	Rochester Cathedral
1962	Westminster Abbey
1963	Chelmsford Cathedral
1964	Westminster Abbey (Princess Mary,
	The Princess Royal officiated)
1965	Canterbury Cathedral
1966	Westminster Abbey
1967	Durham Cathedral
1968	Westminster Abbey
1969	Selby Abbey

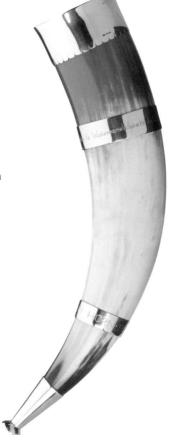

1970	Westminster Abbey (Queen Elizabeth The Queen Mother officiated)	1993	Wells Cathedral
		1994	Truro Cathedral
1971	Tewkesbury Abbey	1995	Coventry Cathedral
1972	York Minster	1996	Norwich Cathedral
1973	Westminster Abbey	1997	Bradford Cathedral
1974	Salisbury Cathedral	1998	Portsmouth Cathedral
1975	Peterborough Cathedral	1999	Bristol Cathedral
1976	Hereford Cathedral	2000	Lincoln Cathedral
1977	Westminster Abbey	2001	Westminster Abbey
1978	Carlisle Cathedral	2002	Canterbury Cathedral
1979	Winchester Cathedral	2003	Gloucester Cathedral
1980	Worcester Cathedral	2004	Liverpool Cathedral
1981	Westminster Abbey	2005	Wakefield Cathedral
1982	St David's Cathedral, Dyfed	2006	Guildford Cathedral
1983	Exeter Cathedral	2007	Manchester Cathedral
1984	Southwell Minster	2008	St Patrick's Church of Ireland Cathedral, Armagh
1985	Ripon Cathedral	2009	St Edmundsbury Cathedral, Bury St Edmunds
1986	Chichester Cathedral		
1987	Ely Cathedral	2010	Derby Cathedral
1988	Lichfield Cathedral		
1989	Birmingham Cathedral		
1990	Newcastle-upon-Tyne Cathedral		
1991	Westminster Abbey		
1992	Chester Cathedral		

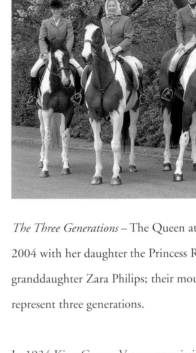

Windsor Castle is the largest continuously occupied castle in the world, and one of The Queen's official residences as Head of State. Although scarcely more than twenty miles from London, the Castle, set within Windsor Great Park, provides a rural alternative to Buckingham Palace. During the months when The Queen's programme is based in London Her Majesty usually travels to Windsor for the weekend. There are also four weeks of the year, around Easter, when The Queen takes up full residence at the Castle. During this period, known as Easter Court, staff who are usually based in London move to Windsor with The Queen.

The Three Generations – The Queen at Windsor in 2004 with her daughter the Princess Royal and granddaughter Zara Philips; their mounts also represent three generations.

In 1934 King George V gave permission for a Scout parade at Windsor Castle. The parade takes place each year on the Sunday closest to St George's Day, 23 April. Winners of The Queen's Scout Award (right), the highest achievable in the British Scout Movement, are inspected by The Queen or another senior member of the Royal Family, accompanied by the Chief Scout.

SPRING

Easter Court

During Easter Court The Queen invites distinguished guests to dinner and to stay the night at the Castle. This event is known as a 'Dine and Sleep'.

Dinner is served in the State Dining Room, and is followed by a tour of the State Apartments. A selection of objects from the Royal Collection and Royal Archives which may have particular relevance to the guests staying that evening will be laid out in the Royal Library.

In 2010 The Queen's guests included the Moroccan Ambassador, Princess Lalla Joumala Alaoui, a cousin of the King of Morocco. The display prepared for the Ambassador included documents and printed books with illuminations of Sultan Mohammad III, who had presented five horses to two of George III's sons in 1790; a volume of Queen Victoria's Journal, and a watercolour from her Souvenir Album describing the visit of Moroccan emissaries in 1850; there was also a letter of 1901 enclosing a portrait of King Edward VII by Sultan Abdal-Aziz.

LE MENU

Truite Saumonée Printanière

———

Noisettes d'Agneau Brehan
Purée de Céleri-rave au Truffe
Chou de Printemps
Pommes Forestière
Salade

———

Tarte Sablé Breton à la Rhubarbe

LES VINS
Meursault les Tillets, Patrick Javillier 2006
Gevrey Chambertin, Domaine Taupenot-Merme 1996
Icewine Riesling, Cedarcreek Estate Winery,
 Okanagan Valley 1995
Royal Vintage Port 1963

At the heart of Easter Court is Easter Sunday, when The Queen and the Royal Family attend Mattins at St George's Chapel in the Lower Ward of Windsor Castle. The Chapel was originally founded in 1348 by Edward III, but in its present form dates from the late fifteenth century.

Throughout the year Her Majesty may visit St George's for other purposes, such as family weddings, memorial services, thanksgivings and, in June, the annual Garter Service (see page 55). For Easter, the High Altar is decorated with chapel plate, dating from the time of Charles II.

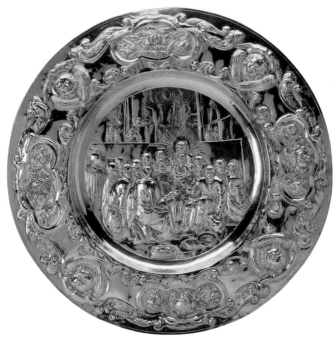

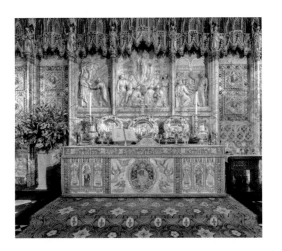

This silver gilt dish is particularly relevant to Easter, as it depicts Jesus and his disciples at the Last Supper. It was a gift to the Chapel in 1662.

The Queen is shown here outside the Deanery on Easter Day receiving a gift of spring flowers.

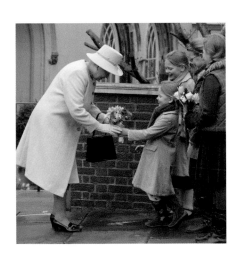

Easter Court

Her Majesty receives around 3,000 birthday cards every year, all of which are acknowledged by The Queen's ladies-in-waiting (below). In 2006, the year of The Queen's eightieth birthday, close to 30,000 were received. They arrive from all over the United Kingdom, the Commonwealth and beyond. Because the various nations of the Commonwealth celebrate The Queen's birthday at different times of the year, the stream of birthday cards never ceases.

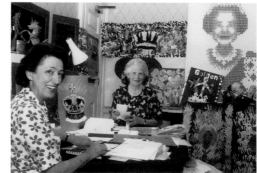

The Queen's birthday on 21 April falls within the period of Easter Court. However, the United Kingdom officially celebrates the occasion in June. The separation of the monarch's actual and official birthdays was begun by King Edward VII, whose birthday on 9 November was invariably marked by poor weather.

Regional visits are of great importance to The Queen as a means of enabling as many people as possible to experience contact with their Head of State. They also provide a valuable focus for the place or organisation that is visited. During the course of her reign, The Queen has been to every part of the United Kingdom, from the Shetland Islands to the Scilly Isles. Her Majesty is always accompanied by one of her ladies-in-waiting and an equerry (a personal aide selected from the armed forces) along with other members of staff.

On a regional visit The Queen will go to a range of places, such as an umbrella factory in East London (top), and a chewing gum factory in Plymouth (centre).

Since the 1970s such outings have included 'walkabouts' so as to enable the maximum number of people to meet The Queen, as here in Romsey, Hampshire in 2007.

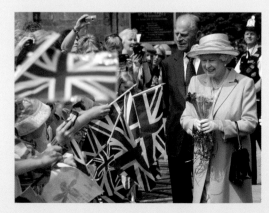

Each year The Queen receives a large number of invitations from a variety of organisations, and the final destinations are selected by her Private Secretary, working closely with the Lord-Lieutenants based in each county.

The Private Secretary ensures that The Queen's visits are spread evenly across the country, and that The Queen has an opportunity to meet the widest range of people in the time available to her.

A regional visit may begin with the presentation of local dignitaries by the Lord-Lieutenant. It can include a business, school, place of worship, heritage organisation, hospital, community scheme or military unit, or one of the 600 charities of which The Queen is patron.

The visibility of the sovereign has always been of crucial importance and The Queen takes care to choose brightly coloured outfits that will enable people to distinguish her easily in a crowded scene.

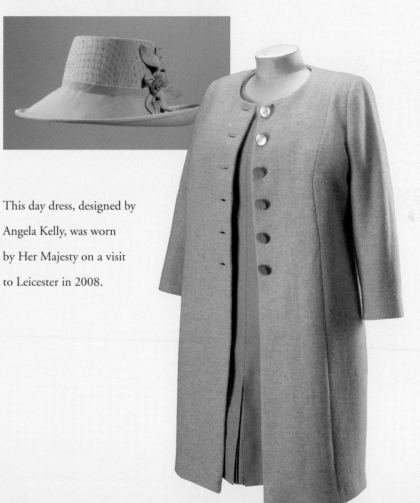

This day dress, designed by Angela Kelly, was worn by Her Majesty on a visit to Leicester in 2008.

This day dress, and the hat designed by Philip Somerville, was worn by Her Majesty on a visit to Somerset in 2007.

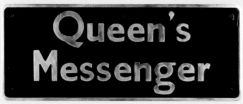

The Royal Train, *The Queen's Messenger,* can be used both for short distances or, if required, for longer overnight journeys. The use of the train means that The Queen is able to work while travelling. Her Majesty also uses scheduled train services when possible.

This replica of the Royal Train's nameplate was presented to The Queen during a visit to Tyne and Wear in 2000.

40

During her reign, The Queen has visited the sets of the soap operas *Coronation Street, Eastenders* and *Emmerdale*, a council flat in Glasgow, a Welsh power station, a variety of places of worship, a London bus depot and two coal mines. In 2010 Her Majesty visited the City of London to review the Company of Pikemen and Musketeers.

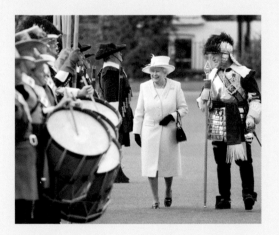

The Queen has received an impressive collection of gifts during her many UK visits. At Aldgate East Underground Station in London, Her Majesty was presented with a unique London Underground sign. Other gifts have included these coasters, made from recycled mobile phone covers, presented during a visit to the global headquarters of Vodafone in Newbury in 2008. In 1996, Her Majesty received this model of the popular characters Wallace, Gromit and Morph whilst at Aardman Animations in Bristol.

Regional Visits

During a visit to the Altnagelvin Hospital in Northern Ireland in 2009, Her Majesty was given this model of a leaf. On this occasion The Queen officially opened a new wing of the hospital.

In Tyneside as part of the Golden Jubilee tour of the United Kingdom in 2002, this colourful glass vase was presented to The Queen.

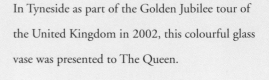

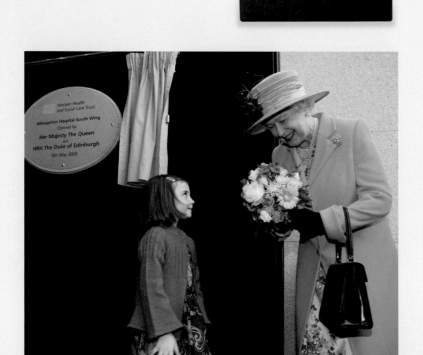

This silver model of a tunnelling machine was presented at the opening of the second Mersey Tunnel in Liverpool in 1971.

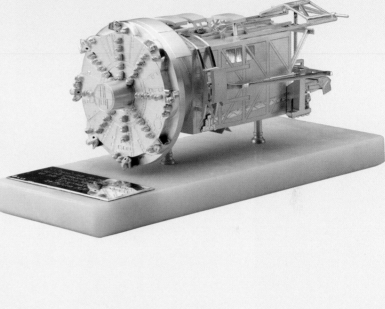

Occasionally The Queen is asked to lay a stone to mark the commencement of work on a new building, or to plant a tree in celebration of her visit. In these cases, she is often given a commemorative trowel or spade, such as the one above, which she used to set the foundation stone of a new building at the Manchester Grammar School in 1965.

This bell was taken from the *British Admiral*, a ship launched by The Queen in 1965 at Barrow-in-Furness. When the ship was sold in 1976 the bell was sent to Her Majesty as a gift.

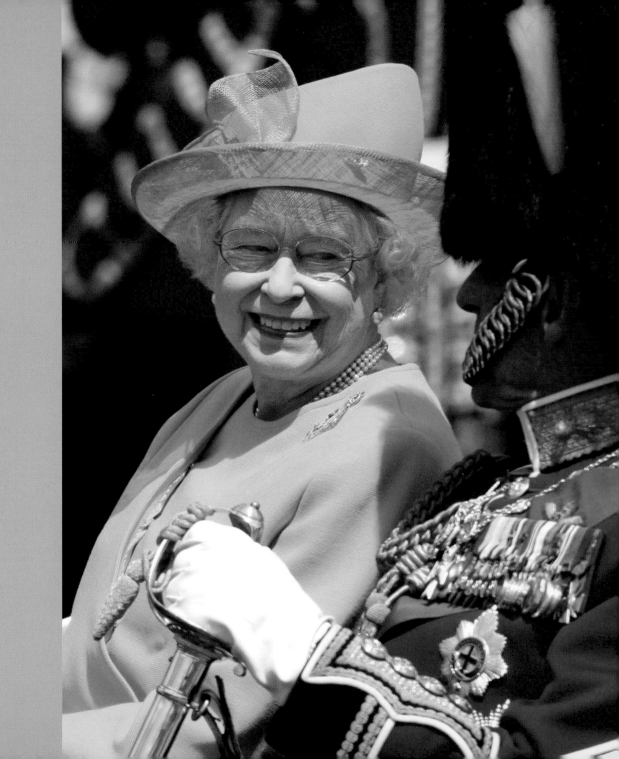

SUMMER

**The Royal Windsor
Horse Show**

This five-day celebration of equestrianism has been held at Windsor in late May since 1943. The Queen's father, King George VI, was patron of the Windsor Horse Show in its early years, a tradition that The Queen has continued. Various members of the Royal Family have taken part in competitions, including the Duke of Edinburgh, who has competed in numerous carriage-driving events. Shown here is a trophy awarded to The Queen in 2004 to commemorate her various successes at the horse show.

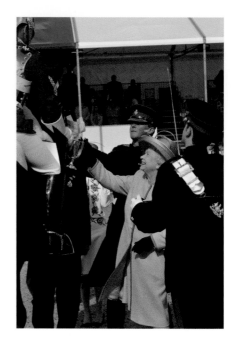

A highlight of the show is the Best Turned-Out Trooper Competition, a hard-fought prize presented personally by The Queen to a member of the Household Calvary.

Close to 3,000 horses and 70,000 people attend the show each year. The Queen was presented with this picture in 1993, the fiftieth anniversary of the show, in recognition of her continuing support.

The Royal Horticultural Society's Chelsea Flower Show, held annually in late May, is the showpiece of the British gardening calendar. The first Chelsea Flower Show was held in 1913, but links with the Royal Family date from 1816 when Queen Charlotte became the Society's royal patron. In the mid-nineteenth century Prince Albert was president. In more recent times Queen Elizabeth The Queen Mother was patron, the position now held by The Queen. Each year Her Majesty visits the Chelsea Flower Show on the evening before it is opened to the public. This painting was presented to Her Majesty when she visited an Australian garden at the show in 2008.

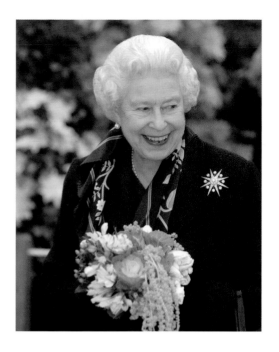

Numerous flowers have been named after members of the Royal Family, including the Queen Elizabeth rose, named after Queen Elizabeth The Queen Mother in 1954.

Trooping the Colour

Each June, to mark Her Majesty's official birthday, Horse Guards Parade in London becomes the setting for one of the grandest and most symbolic of all royal events – Trooping the Colour. The ceremony has a long history, deriving from the practice of carrying distinctive regimental flags or colours along ranks of soldiers so they could be recognised and used as rallying-points during battle. The occasion was first associated with the sovereign's birthday in 1748, during the reign of George II.

By the accession of George IV in 1820 it had become an annual fixture. King Edward VII was the first monarch to receive the salute in person.

King George V made alterations to the ceremony to provide more of a spectacle for the increasing crowds. After the ceremony, he rode down The Mall back to Buckingham Palace at the head of his troops. In modern times the event is broadcast on television and is enjoyed by viewers around the world.

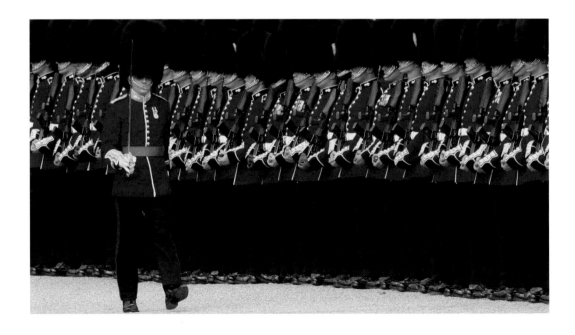

Trooping the Colour

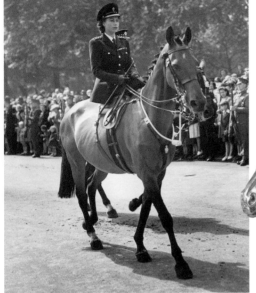

Her Majesty first appeared at the Trooping in 1947. This was the first Birthday Parade to be held after the end of the Second World War and Princess Elizabeth participated as Colonel of the Grenadier Guards. This sculpture by Doris Lindner was made to commemorate the occasion, which was conducted in battle dress. The Princess wore a blue uniform and forage cap, which later became the uniform of the Women's Royal Army Corps.

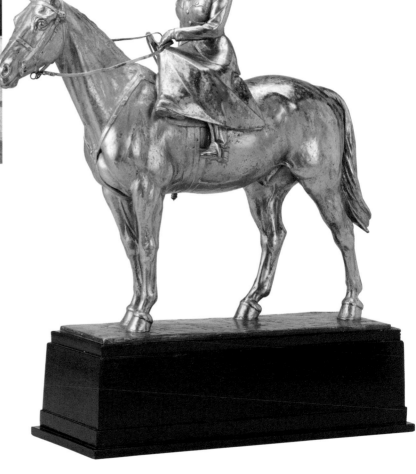

49

Trooping the Colour

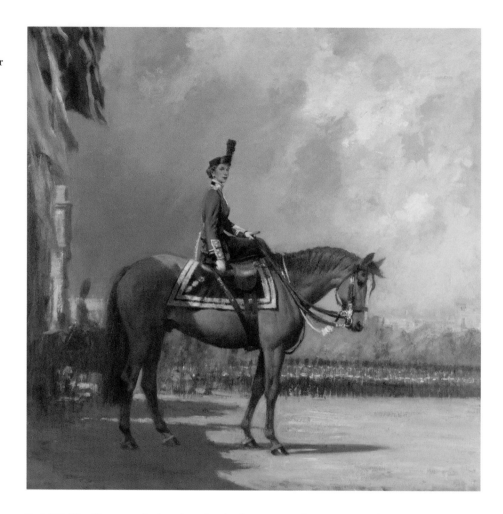

In 1951 The Queen took the salute for the first time, deputising for her father who was unable to attend due to illness. With the exception of 1955 when the parade was cancelled owing to a rail strike, Her Majesty has attended every year since, demonstrating the importance she attaches to the event. In 1954 Edward Seago painted this equestrian portrait of The Queen on horseback wearing the uniform of Colonel-in-Chief of the Coldstream Guards.

Until 1986, Her Majesty took the salute on horseback, using the side-saddle shown here and wearing this scarlet tunic and tricorn hat. Elements of the design – such as the colour of the plume – would be changed depending on the regiment whose colour was trooped. The Duke of Edinburgh has always accompanied The Queen, wearing the uniform of Colonel of the Grenadier Guards.

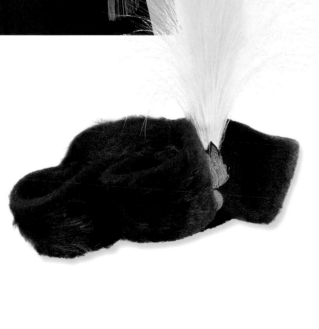

51

Trooping the Colour

In 1969 the Royal Canadian Mounted Police presented The Queen with Burmese, a black mare, who remained The Queen's favoured horse for Trooping the Colour for many years. Since 1986 The Queen has travelled to the Trooping in an ivory-mounted phaeton carriage designed for Queen Victoria in 1842. This one-third-scale bronze sculpture of Burmese was presented to The Queen in 1987 by the St John Ambulance Brigade.

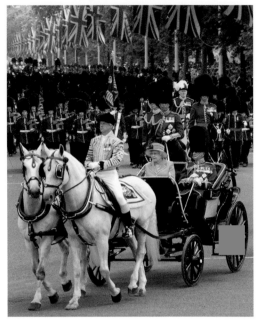

The Queen pauses on her way up to the balcony of Buckingham Palace to offer her horse a reward after the parade.

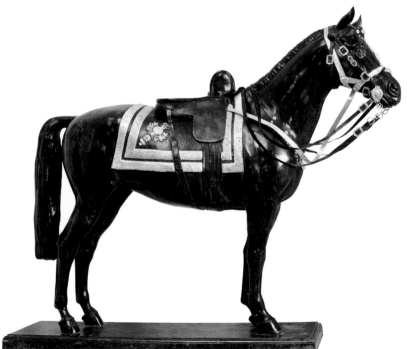

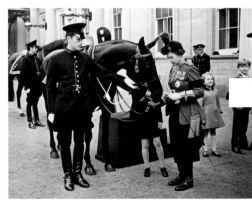

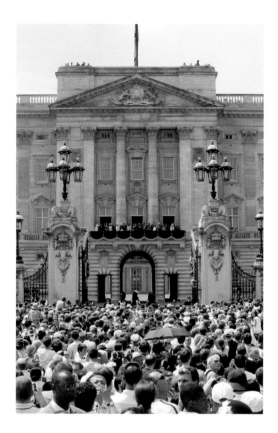

Trooping the Colour, more than any other event, proclaims The Queen's role as head of the armed forces of the United Kingdom; whilst also marking Her Majesty's official birthday.

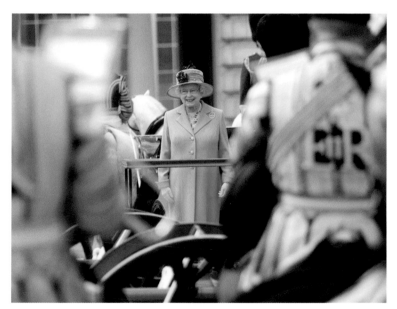

In modern times, the climax of the day has been the appearance of The Queen and the Royal Family on the balcony, to greet the crowd and watch a fly-past by the Royal Air Force.

Trooping the Colour

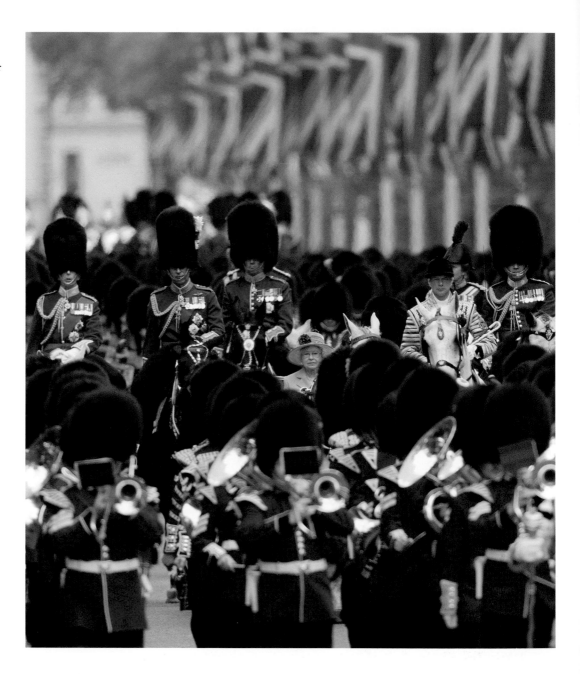

In mid-June, The Queen leads the celebration of Garter Day at Windsor. The Most Noble Order of the Garter, founded in 1348 by Edward III, is the oldest and the most senior order of chivalry in England. Originally, membership was awarded for success on the battlefield and in tournaments. Its patron saint is St George, and its spiritual home is St George's Chapel in Windsor Castle. The annual enactment of this picturesque and historic ceremony was largely in abeyance from 1674, until its revival in 1948 by King George VI.

The Black Book of the Garter (below) dates from the 1530s, during the reign of Henry VIII, and records the names and arms of all the Knights. Its series of painted and gilded illustrations show Henry enthroned and surrounded by his Garter Knights, and an early representation of a Garter procession. In 2007, a modern Garter Book was made, containing the names and arms of all current members of the Order, including those of Sir Edmund Hillary and the Duke of Wellington (right). In addition to the Royal Knights and Ladies there are twenty-four Knight Companions of the Order.

Sir Edmund Hillary

The Duke of Wellington

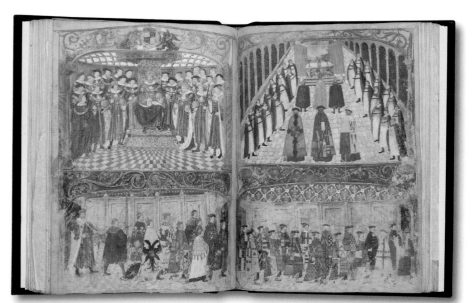

Garter Day

The Order of the Garter is entirely in the gift of the sovereign. New appointments to the Order are announced on St George's Day, 23 April, and new members are invested in the Garter Throne Room in Windsor Castle on Garter Day.

The Order consists of those who have held senior public office, contributed significantly to national life or provided outstanding service to The Queen. A number of Prime Ministers have been honoured in this way, along with Governors-General and other leading figures from public life and the armed forces.

The Queen was invested by King George VI as a Lady of the Garter (top left) not long before her wedding in 1947.

Many foreign monarchs have been appointed to the Order of the Garter, including Napoleon III, Emperor of France, who was invested by Queen Victoria during a visit to Windsor in 1855, an event commemorated by E. M. Ward (below left).

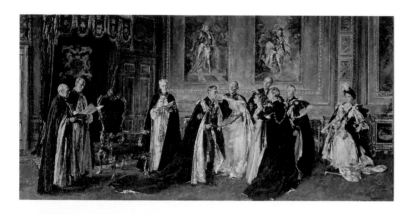

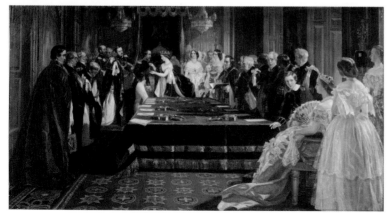

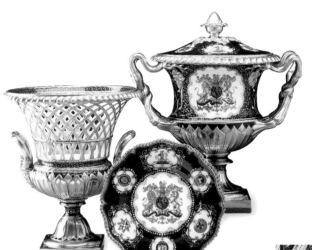

In 1672 the scholar Elias Ashmole published an account of the Order entitled *Institution, Laws and Ceremonies of the Order of the Garter.* The etchings by Wenceslaus Hollar provide an excellent visual record of Garter celebrations at Windsor Castle during the mid-seventeenth century, including the Garter feast in St George's Hall.

On the day of the celebration the members of the Order meet for a luncheon in the Waterloo Chamber at Windsor Castle. A spectacular Worcester porcelain service, commissioned by William IV in 1831 and bearing the badges of the orders of chivalry of the United Kingdom, is always used. After the luncheon, the Knights and Ladies put on their mantles, and process to St George's Chapel for the service of dedication and thanksgiving.

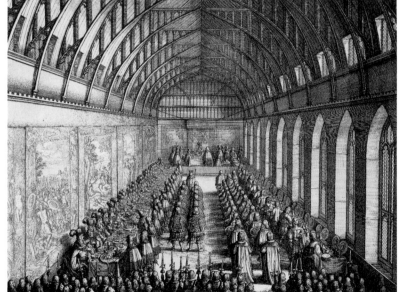

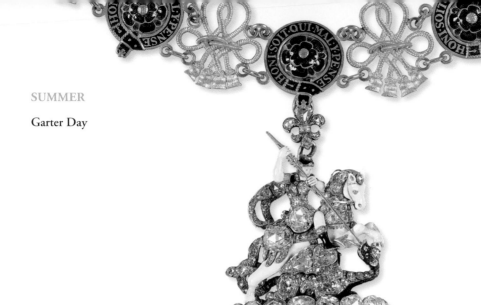

Garter Day

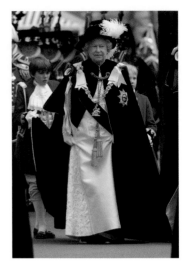

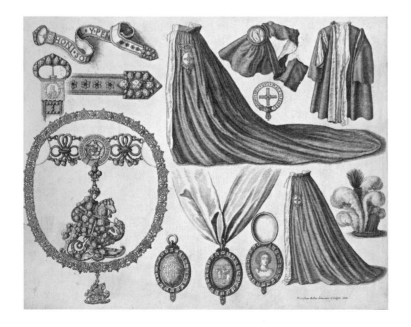

Hollar's etchings also record the insignia and robes worn in the seventeenth century. When compared to those worn today, it is clear that little has changed. The Knights still wear a blue velvet mantle with the badge of the Order on the left shoulder, and a vestigial red hood worn over the right shoulder, a black hat garnished with white feathers and the Great George suspended from a Garter Collar. The Great George is a pendant in the shape of St George slaying the dragon. The Queen wears the diamond-encrusted Marlborough George (above left) made for George IV in 1825.

The procession is led by the Heralds – members of The Queen's Household with expertise in heraldic, genealogical and ceremonial matters. They are distinguishable by their bright tabards, little changed in design since the 1830s.

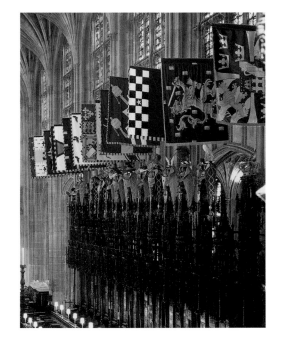

Each Knight is allocated a stall in the quire of St George's Chapel, which is demarcated by his helm, banner and crest (above). The crests are made by a specialist sculptor; the Heralds advise on their symbolism and colourings.

Garter Day is a public event, and many people bring picnics and settle in the Middle and Lower Wards of the Castle to enjoy the spectacle and pageantry of this most picturesque and historic event.

Royal Ascot

The royal association with the racecourse at Ascot goes back three hundred years. It was laid out on the orders of Queen Anne in 1711 on royal land which remains part of Windsor Great Park. By the reign of George III it had become an important meeting place of society and fashion, and races there were regularly attended by members of the Royal Family. The scene below is Paul Sandby's record of a race meeting at Ascot in the 1760s.

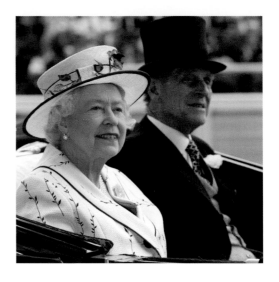

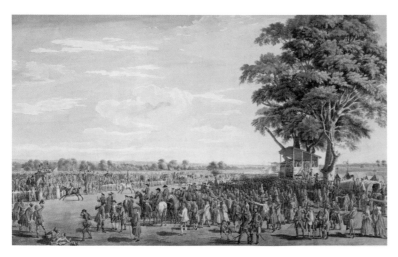

King Edward VII, another great horse-racing enthusiast, set the pattern for Royal Ascot week, which occurs in June every year. The Queen is a keen follower of horse-racing, and maintains around forty horses of her own in training. She has attended Royal Ascot every summer since 1945.

The royal racing colours – a purple body with gold braid, scarlet sleeves and a black velvet cap with gold fringe – were first used by the Prince Regent, later George IV, in the 1810s.

The painting (below) by Sir Alfred Munnings, showing The Queen with her racehorse Aureole, her trainer Captain Cecil Boyd-Rochfort and the jockey Eph Smith, was presented to The Queen in 1957. Aureole was one of Her Majesty's most successful horses. He won the King George VI and Queen Elizabeth Diamond Stakes and the Hardwicke Stakes at Royal Ascot, and was champion sire in the British Isles in 1960 and 1961.

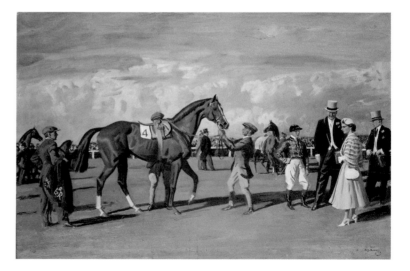

Royal Ascot

During Royal Ascot The Queen entertains a number of guests at Windsor Castle. On Gold Cup Day, the third day of the meeting, a luncheon takes place in the State Dining Room. The table is decorated with The Queen's trophies from past meetings.

The Queen and her guests then travel to the racecourse, first by car, and then in carriages for the last leg of the journey.

In recent years interest has grown in the colour of the hats worn by The Queen at Royal Ascot. On the left are three hats worn in 1968 (top), 1991 (centre) and 2008 (below).

Her Majesty was presented with this small silver box showing the new stand at the racecourse, completed in 2006. A glass horse's head, by the famous French manufacturer Lalique, was presented to The Queen in 1953, and is kept in the Royal Box at Ascot.

The Queen has enjoyed many successes at Ascot, especially with horses such as Aureole and Choir Boy in the 1950s and 1960s, and with Highclere and Dunfermline in the 1970s. Trophies include these won by Aureole in 1954 (right), and by Buttress in1979 (below).

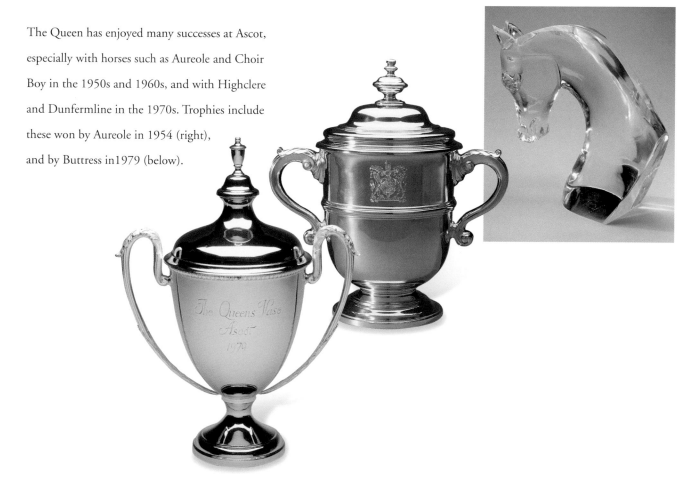

Garden Parties

Garden parties have been held at Buckingham Palace since the 1860s, when Queen Victoria began to give what were called 'breakfasts' at the time, even though they were held in the afternoon. This painting by Laurits Tuxen shows Queen Victoria attending a garden party at the Palace in 1897, the year of her Diamond Jubilee.

Until 1952, two garden parties took place each year in London, but in the present reign there have always been three. The parties have evolved, with encouragement from The Queen and the Duke of Edinburgh, to include a broad cross-section of society. At each modern garden party there are about 8,000 guests, consuming around 27,000 cups of tea, 20,000 sandwiches and 20,000 slices of cake.

An invitation to a garden party is an acknowledgement from The Queen for some kind of service or contribution to national life. Recommendations are requested from a large number of national organisations and institutions including the government, Civil Service, armed forces, Diplomatic Corps, charities and other benevolent societies. The Lord-Lieutenant in each county is responsible for co-ordinating nominations for invitation.

Garden parties take place from 4 to 6 o'clock in the afternoon. The Queen and other members of the Royal Family enter the garden at around 4 o'clock and are greeted with the National Anthem, played by one of two military bands, which continue to play throughout the afternoon.

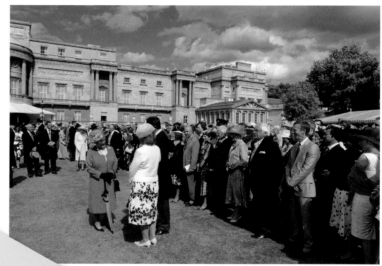

E⁷R

The Lord Chamberlain is
commanded by Her Majesty to

The Lord Chamberlain is
commanded by Her Majesty to invite

to a Garden Party
at Buckingham Palace
on Tuesday, 22nd June 2010 from 4 to 6 pm

This card does not admit

on '1

This card does non

Garden Parties

The two Corps of The Queen's Ceremonial Bodyguard – the Yeomen of the Guard and the Gentlemen at Arms – are both on duty. The Yeomen form the guests into lanes, down which members of the Royal Family walk. Gentlemen Ushers in their morning coats walk down the lanes and select guests for The Queen and Royal Family to meet. In this way the maximum number of people are able to meet The Queen.

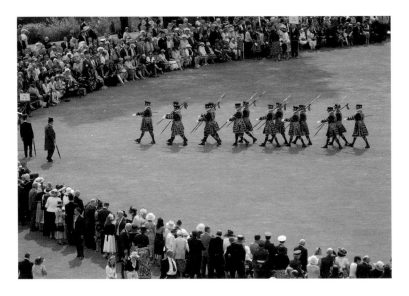

The royal party eventually arrive at the Royal Tea Tent, which is decorated with pieces from the silver gilt Grand Service, commissioned by George IV in the early nineteenth century.

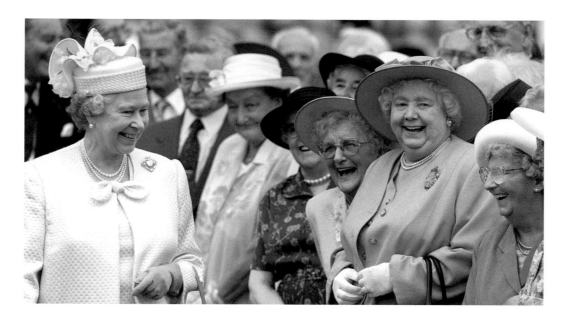

In addition, The Queen may hold further special garden parties. Such events have a theme, celebrating an anniversary or expressing gratitude to a certain section of society. In recent years, garden parties have been held to celebrate the Territorial Army's 100th anniversary and the centenary of the British Red Cross's Royal Charter. In 1997, to mark their Golden Wedding anniversary, The Queen and the Duke of Edinburgh invited 4,000 couples who were celebrating the same milestone that year (above).

In 2006, in celebration of The Queen's eightieth birthday, a spectacular children's garden party was staged (below), with special guests from children's fiction, television and film.

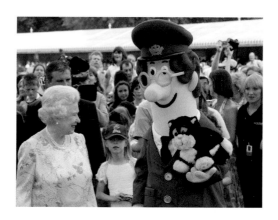

Holyrood Week

The Palace of Holyroodhouse has been associated with Scottish royalty since 1128, and it remains The Queen's official residence in Edinburgh. Holyrood Week is usually at the end of June or beginning of July. The Queen takes up residence at the Palace and presides at a series of engagements and occasions that celebrate Scottish culture, history and achievement.

The arrival of The Queen at the Palace is marked by the Ceremony of the Keys, at which the Lord Provost of Edinburgh hands The Queen the keys to the city and greets her with the words 'Welcome to your ancient and hereditary kingdom of Scotland'.

The Queen is then handed the key to the Palace by a member of the Palace staff.

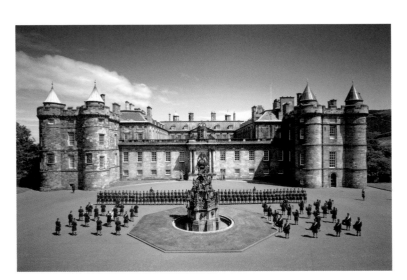

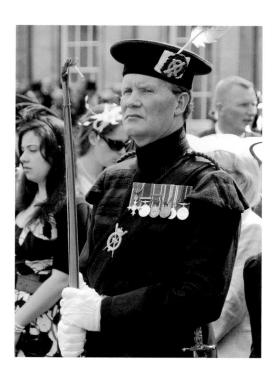

Whilst in Scotland, The Queen is attended by her ceremonial guard, the Royal Company of Archers and the Lord High Constables of the Palace of Holyroodhouse.

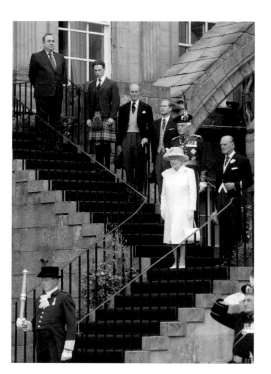

Holyrood Week allows The Queen to perform many of her engagements in a setting specific to Scotland. A garden party is held in the grounds of the Palace in the shadow of Arthur's Seat, a spectacular outcrop in the surrounding landscape.

The High Constables are distinguishable by their bright blue uniforms and their batons, such as the one shown on the right.

A regular feature of Holyrood Week is the Thistle service at St Giles's Cathedral. The Order of the Thistle, instituted in 1687 by James VII of Scotland (James II of England), is the highest order of chivalry in Scotland. It is reserved for those who have made an important contribution to the national life of Scotland and is, like the Order of the Garter, entirely in the gift of The Queen. New Knights are installed at the Chapel in the Cathedral. New appointments are made on St Andrew's Day (30 November).

For the service, The Queen wears the dark green velvet mantle of the Order, together with a collar decorated with thistles, and a badge showing St Andrew holding his cross. The star bears the Order's motto, *Nemo me impune lacessit* ('No-one harms me with impunity').

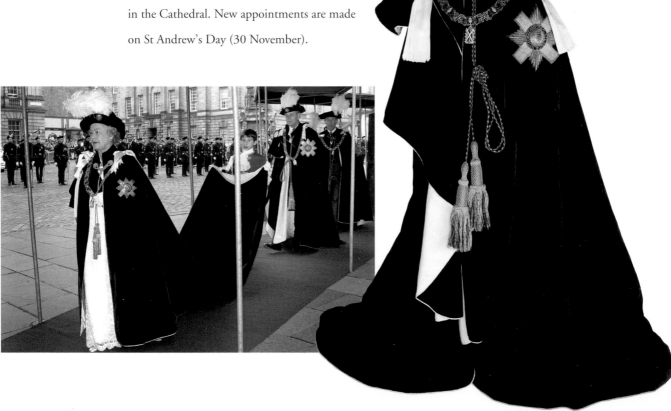

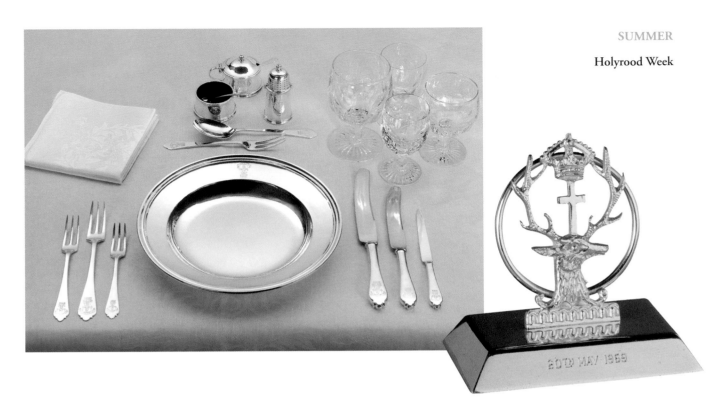

Holyrood Week is a busy time, full of official functions, engagements and dinners. For the dinners, items from a 3,000-piece banqueting service are used. Made in Edinburgh, it is engraved with the Scottish version of the Royal Coat of Arms and was presented to King George V and Queen Mary to commemorate the King's Silver Jubilee in 1935.

This silver menu-holder is part of a set that was made in Edinburgh by the silversmiths Hamilton & Inches, and presented to The Queen in 1969 by the High Constables of Holyrood. The design refers to the story of the foundation of Holyrood, when David I had a vision of a stag with a cross, or 'rood' between its antlers, prompting him to found a monastery on the site.

The Queen is never entirely on holiday and continues to receive her official boxes while she is at Balmoral. As well as being Head of State, The Queen also takes a personal interest in the running of the Royal Household. Her response to a variety of different issues ranging from important affairs of state to routine questions may be required at all times. Because of this, many members of The Queen's Household travel with her wherever she goes.

Since 1993, for the two months of The Queen's residence in Scotland, the state rooms of Buckingham Palace are open to the public.

At the end of July, after two weeks back in London for a busy round of audiences, further garden parties and investitures, The Queen returns to Scotland, this time travelling further north to her private residence, Balmoral Castle.

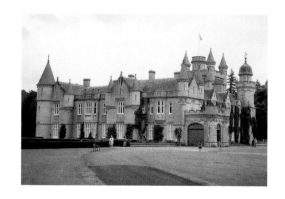

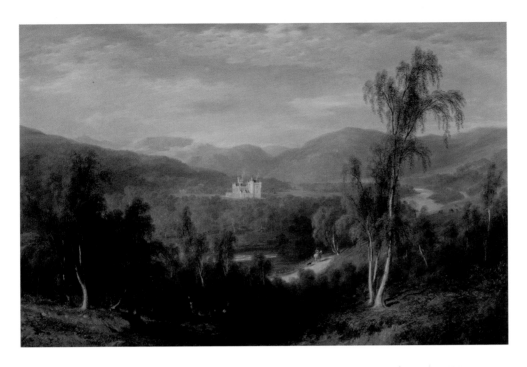

The Royal Family's association with Balmoral began in 1848, when the lease of the estate was acquired for Queen Victoria. The original Castle, shown in this oil painting by James Giles, was not considered large enough, and Prince Albert had it replaced with a more modern house of his own design, which was completed in 1856. The Castle's secluded position, away from the pressure of London life, has ensured its continued popularity with the Royal Family.

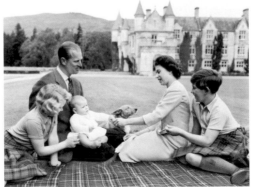

Her Majesty has visited Balmoral nearly every summer of her reign. The photograph above shows the Royal Family enjoying a visit in 1960.

73

The Braemar Gathering is held on the first Saturday in September. This celebration of Highland culture and sportsmanship has taken place in some form for around 900 years. Royal association with the event began when Queen Victoria first attended in 1848. In 1887 the gathering was held at Balmoral to commemorate the Queen's Golden Jubilee. The games include events such as caber-tossing, and stone- and hammer- throwing, along with track events, traditional piping, dancing and a tug-of-war.

This day dress by Stewart Parvin was worn by Her Majesty to the Braemar Gathering in 2009.

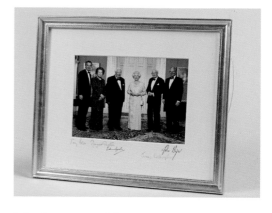

It has become usual for the Prime Minister to pay a visit to Balmoral on the weekend of the Gathering. The tradition dates from the reign of Queen Victoria, when it took much longer for the Prime Minister to reach the Highlands from London. The framed photograph above hangs in the Prime Minister's bedroom at the Castle, and shows The Queen with five of her Prime Ministers, each of whom has signed it.

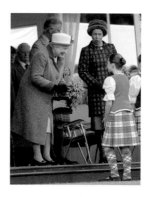

The estate of Balmoral covers 20,000 hectares. It is very much a working estate with its own community of the kind once common in the Highlands. It contains some of the most spectacular scenery and wildlife to be found in the region, including 1,000 hectares of the ancient Ballochbuie Forest. Around fifty people are employed on the estate, and The Queen makes sure that she sees them all during the course of her annual stay. An ideal opportunity to do so is at one of the two Ghillies' Balls, held for staff, members of the local community and soldiers from the Royal Guard stationed at Ballater.

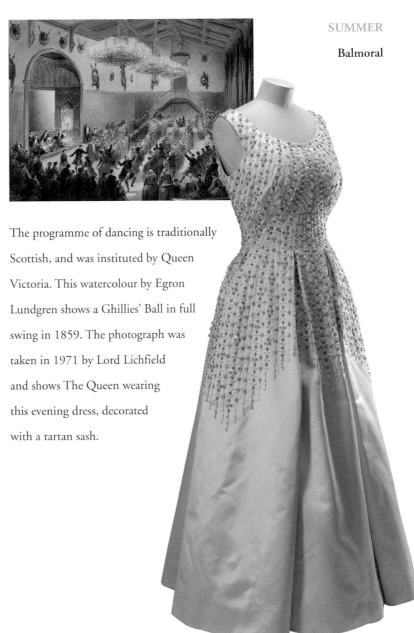

The programme of dancing is traditionally Scottish, and was instituted by Queen Victoria. This watercolour by Egron Lundgren shows a Ghillies' Ball in full swing in 1859. The photograph was taken in 1971 by Lord Lichfield and shows The Queen wearing this evening dress, decorated with a tartan sash.

75

AUTUMN

On the eleventh hour of the eleventh day of the eleventh month, the time of the signing of the armistice at the end of the First World War in 1918, it is traditional in the United Kingdom for two minutes' silence to be observed to remember those who have fallen in the service of their country. On the Sunday closest to that day, the Service of Remembrance takes place at the Cenotaph in Whitehall.

The Queen is head of the armed forces, and several members of the Royal Family have served or are serving in the forces. This is therefore an occasion that Her Majesty has always observed with the utmost solemnity – acting as a focus for the national act of remembrance. The Queen first appeared at the Cenotaph in 1946, at the first ceremony after the end of the Second World War.

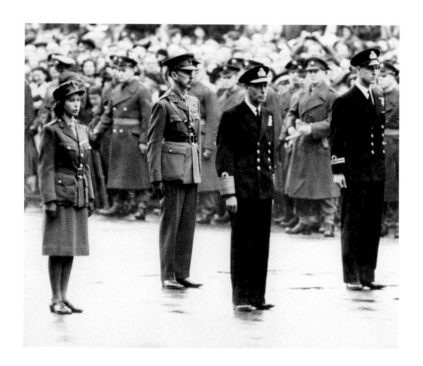

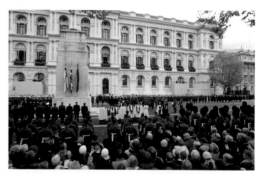

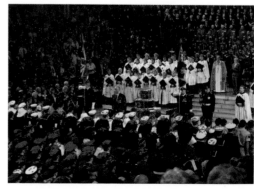

On the evening before the service, The Queen attends the Festival of Remembrance, an annual event staged by the Royal British Legion at the Royal Albert Hall in London. It is attended by serving troops, their families, and members of the British Legion. The Festival comprises a sequence of musical performances, culminating in the release of thousands of poppy petals from the ceiling, a moment which is laden with poignancy and symbolism (bottom left).

At both the Festival and the Cenotaph service, The Queen wears a special poppy corsage. The processional cross of the Chapel Royal at St James's Palace is decorated with poppies and processed to the Cenotaph for the ceremony.

When Big Ben strikes 11 o'clock the nation is united for two minutes' silence. The Royal Family stand near the leaders of all the main political parties and religious faiths and a large gathering of war veterans, to remember the sacrifice of those who lost their lives in the service of their country. A gun is fired on Horse Guards Parade to end the silence, at which point The Queen lays her wreath on the Cenotaph. The wreath is made by the Royal British Legion Poppy Factory and is decorated with The Queen's own ribbon. It bears the inscription *In Memory of the Glorious Dead*, and is signed *Elizabeth R.*

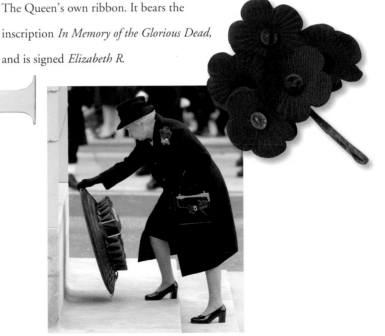

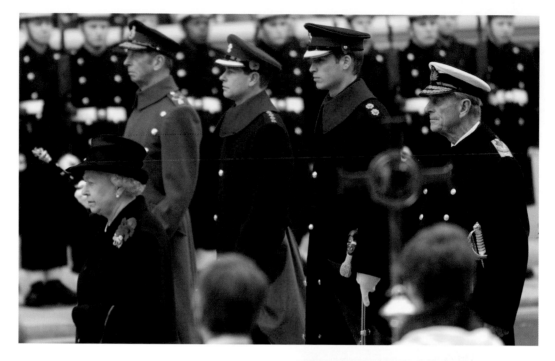

Gathered around the Cenotaph are senior
representatives of the armed and civil forces,
and a massed band drawn from the Army,
Royal Marines and Royal Air Force. The choir
of the Chapel Royal lead the singing of the hymn
'O God, Our Help in Ages Past'. In their state
coats they, along with the red of the poppies, are
the only flashes of colour in this solemn scene.

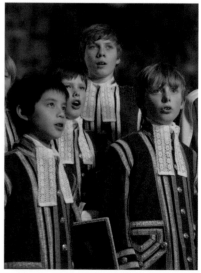

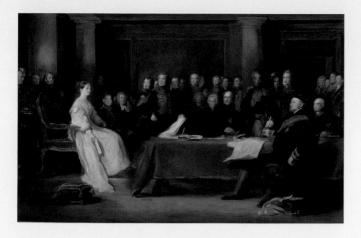

The painting by Sir David Wilkie shows the eighteen-year-old Queen Victoria presiding at her first Privy Council meeting at Kensington Palace in 1837.

The Privy Council is the oldest legislative body in the United Kingdom, tracing its history to the eleventh century. In its early days, the Council was indeed 'privy' or private, and was the foremost decision-making body in the government, with Parliament playing a subordinate role. Today its business is fully in the public domain, and it retains only formal functions, such as the renewal of Royal Charters, the appointment of High Sheriffs for England and Wales, and the approval of various proclamations and orders.

Privy Council meetings are chaired by the monarch and are held regularly at Buckingham Palace or Windsor Castle, and sometimes at Holyrood or Balmoral. At Buckingham Palace the meeting takes place in the 1844 Room. The table is always set up in the same way, ready for any documents that need to be signed or sealed.

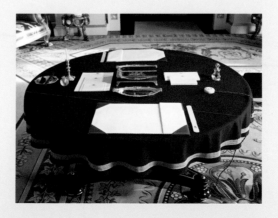

Privy Council Meetings

There are currently over 400 Privy Counsellors, appointed from various sections of public life, who are summoned depending on the agenda for a particular meeting. Since the death of Prince Albert, when the councillors stood as a mark of respect to Queen Victoria, the meetings have been held standing up, as here in 1968.

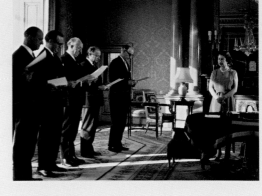

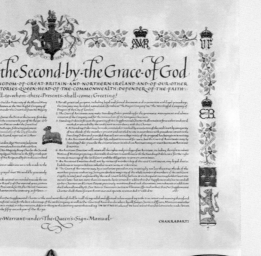

One of the most important roles the Council fulfils is the granting of Royal Charters of Incorporation which are awarded to governmental and professional bodies. The charter shown here was reissued to the Draper's Company of the City of London in 2008. Royal Charters are also used to create cities and towns, and confirm the incorporation of universities and various benevolent organisations. Proclamations become official once the Great Seal of the Realm has been affixed. This seal has been used since 2001. The obverse (left) shows The Queen enthroned and robed, holding an orb and sceptre, while the reverse shows the Royal Coat of Arms.

At Privy Council meetings coins are authorised as currency, the dates of annual bank holidays are fixed, and Parliament can be dissolved or prorogued. The Council also formally appoints members to regulatory professional bodies such as the General Medical, Dental and Optical Councils. This is a tradition that comes from the awarding of charters to the medieval crafts guilds, all of which still maintain Royal Charters.

The objects used during a Privy Council meeting include the silver inkstand (left), given to King George V by Queen Alexandra in 1910; this early Victorian silver dish (below), used as a pen tray; and the late Victorian candlestick (right), used to hold a candle to melt sealing wax. During Council sessions The Queen also uses special pens (above) which are marked with her cipher.

83

**The Diplomatic
Reception**

The Diplomatic Reception at Buckingham Palace is the main event in London's diplomatic calendar. Over 1,200 guests are invited to the annual reception in early November, making it by far the largest of The Queen's receptions inside the Palace. Representatives from over 130 countries are invited, and many attend in national dress.

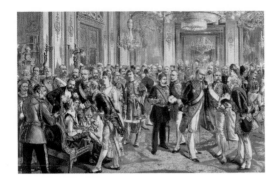

The event has a long history. This illustration from the *London Illustrated News* shows the future King Edward VII presiding at a reception in St James's Palace in 1891.

The Queen's arrival at the reception is heralded with a fanfare by the State Trumpeters (far left). The Marshal of the Diplomatic Corps (left) is always present at the Diplomatic Reception. A member of The Queen's Household, the Marshal is usually a retired senior member of the armed or diplomatic services. It is his responsibility to present senior members of every diplomatic mission to The Queen.

LE MENU

Volaille aux Poireaux et Champignons Sauvages

Ragoût de Lotte et Turbot au Safran

Riz Braisé aux Champignons et Courges

Légumes Variés
Pommes Nouvelles
Pommes Dauphinoise

———

Mousse au Chocolat Chantilly
Yaourt Brûlé aux Cassis

LES VINS
Chardonnay, Les Fleurs, 1998
Ruinart N.V.

The event is highly symbolic, since when high commissioners and ambassadors are sent to the United Kingdom, they present their Credentials to The Queen, and are accredited to her Court of St James, not to the government. The Diplomatic Reception represents the importance of The Queen in the nation's diplomatic relations.

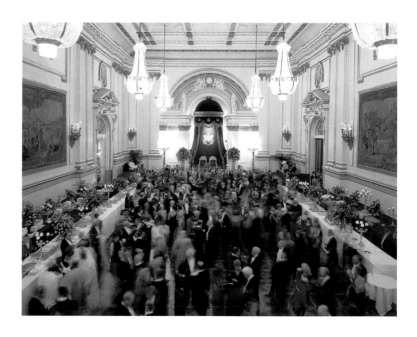

Catering at the Diplomatic Reception is a complicated affair because many different tastes, cultures and religions must be considered. As at all receptions held at the Palace, The Queen aims to meet as many people as possible.

The State Opening
of Parliament

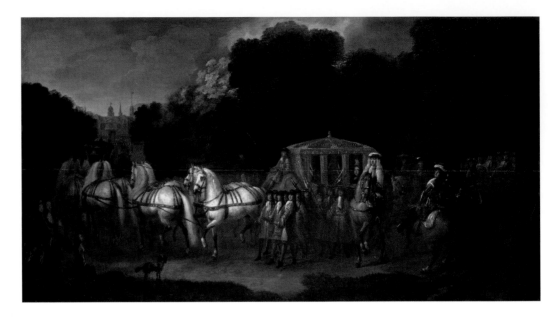

No event better represents The Queen's position as Head of State than the State Opening of Parliament. It is steeped in tradition and ritual, and is the only time when the executive, legislature and crown are together in the same place. A ceremony of this kind has taken place since at least the sixteenth century. The painting above shows Queen Anne making her way to the State Opening of Parliament in the early eighteenth century.

The Queen has opened Parliament in every year of her reign, except 1959 and 1963 when she was expecting her two youngest children. In 1978 the Polish artist Feliks Topolski made this sketch of the ceremony.

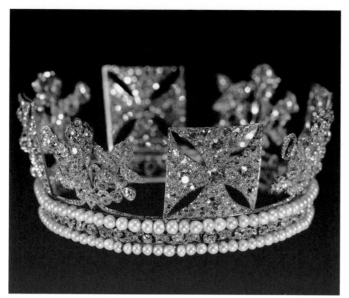

The State Opening usually takes place at the end of November or beginning of December, but can happen at any time of year if a general election has been held. The day begins with the arrival of The Queen's Ceremonial Bodyguard – the Yeoman of the Guard at the Palace of Westminster. With the aid of their lanterns (right), they undertake a search of the cellars of the Houses of Parliament – a tradition instituted following the Gunpowder Plot in 1605.

Her Majesty leaves Buckingham Palace in a State Coach, accompanied by the Duke of Edinburgh. She is preceded by the Imperial State Crown in a carriage of its own, accompanied by senior members of the Royal Household. For her journeys to and from the Palace of Westminster The Queen wears the Diamond Diadem (above left), made for George IV in 1820.

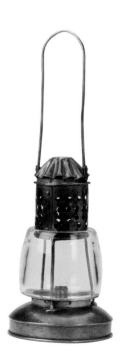

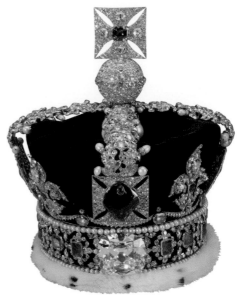

**The State Opening
of Parliament**

Soon after arriving, Her Majesty retires to the
Robing Room to put on her Robe of State and
the Imperial State Crown. The robe was worn
at the Coronation in 1953 and at every State
Opening since. Decorated with two rows of gold
braid, it is 5.5 metres (18 feet) long and four
Pages of Honour are required to carry it
behind The Queen.

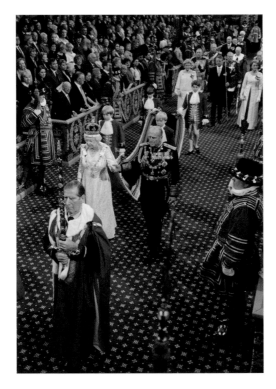

Made for King George VI in 1937, the Imperial
State Crown (above) is the most powerful symbol
of royal authority. Wearing the crown and robe,
The Queen arrives in the Royal Gallery,
announced by a fanfare from the State
Trumpeters. The procession is watched over by
the Yeomen of the Guard and the Gentlemen
at Arms, and is preceded by the Heralds.
The Queen is accompanied by the Duke of
Edinburgh, wearing his full dress uniform of
Admiral of the Fleet, and two ladies-in-waiting
who follow behind the Pages of Honour.

Two maces (one shown far left) are borne by the Serjeants at Arms. These evolved from weapons carried by the sovereign's personal bodyguard, and have come to represent royal authority. Those used today also date from the seventeenth century, and each weighs about 10.4 kg (23 lbs).

The Cap of Maintenance (below) is also processed before The Queen. Made of crimson velvet and trimmed with ermine, it is an ancient symbol of rank and honour.

The Great Sword of State (right) is carried before The Queen by a specially appointed Gentleman Usher. The sword, which dates from 1678, has a scabbard covered in crimson velvet and decorated with national symbols, including a silver gilt portcullis representing Parliament.

The most important part of the State Opening is The Queen's Speech, which Her Majesty reads from the throne, outlining the government's plans for the coming year. The speech is presented to The Queen by the Lord Chancellor in this ornately embroidered purse.

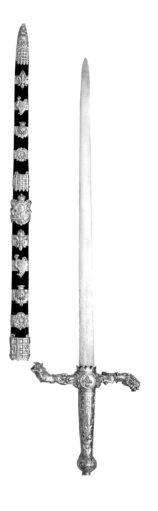

State Visits

Visits between Heads of State have an illustrious history. In most years The Queen will receive at least two incoming state visits, and will usually pay two state visits abroad. These visits are of crucial importance for strengthening the relationship and exchange between nations, in terms of trade, diplomacy and culture. Incoming visits follow a pattern and usually last two or three days. On the first day the visiting Head of State and their spouse are formally welcomed by The Queen and the Duke of Edinburgh.

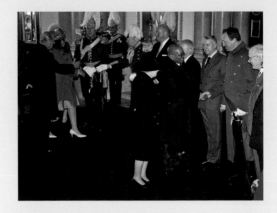

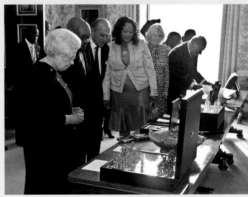

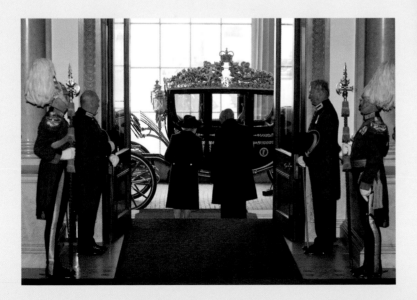

The Queen then presents senior members of the Royal Household to the visitor (top). After a luncheon, gifts and sometimes decorations are exchanged, as during the visit of the President of South Africa in 2010.

The central event of the state visit is the state banquet. At Buckingham Palace the banquet is held in the Ballroom, where the table is arranged in a horseshoe shape, with The Queen and the visiting Head of State at its head.

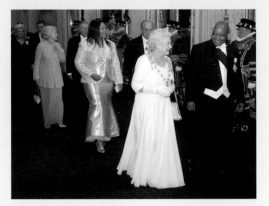

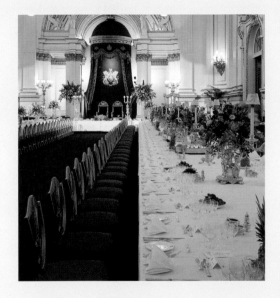

During dinner, speeches and toasts are made by The Queen and the visiting Head of State. The end of the banquet is announced by the arrival of twelve pipers drawn from the Scots or Irish Guards, joined by The Queen's Piper.

If the state visit is at Windsor, the banquet is held in St George's Hall on a 53-metre (174-foot) table made in 1846. The table is decorated with flowers and the finest pieces from George IV's Grand Service of silver gilt. The principal guests process into the banquet led by The Queen and the visiting Head of State.

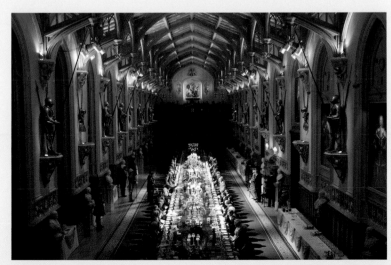

The Queen is the most widely travelled British monarch in history, undertaking two official or state visits abroad most years and attending the Commonwealth Heads of Government Meeting every two years. Her Majesty has paid three hundred and twenty five visits abroad since 1952. The Queen wore this magnificent dress at a state visit to the Netherlands in 1958; it was designed by Norman Hartnell.

The Queen's State Visit to China in 1986 was the first ever paid to that country by a British monarch, as was Her Majesty's visit to Russia in October 1994.

Recent state visits have been paid to Lithuania, Latvia and Estonia in 2006, and Slovenia and Slovakia in 2008. In 2007 The Queen paid a state visit to the USA to commemorate the 400th anniversary of the establishment of the colony of Jamestown in Virginia.

The Queen receives official gifts during state visits. In 2009, to commemorate his state visit to Britain, the President of Mexico presented The Queen with this lacquer plate.

In Slovakia in 2008 The Queen received this wooden panel decorated with winged silver horses, entitled the *Power of Eternity*.

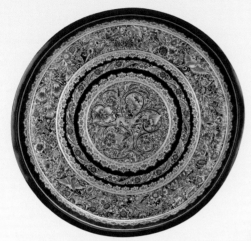

During the South African State Visit to Britain in 2010, The Queen was given this colourful ceramic dish, decorated with cheetahs.

The most recent Commonwealth Heads of Government Meeting, was held in Trinidad and Tobago (left), where Her Majesty was presented with this cricket bat signed by the West Indian batsman Brian Lara.

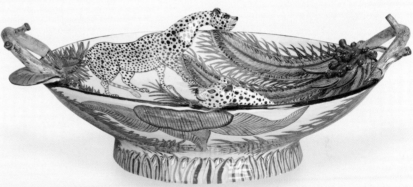

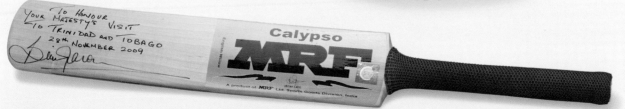

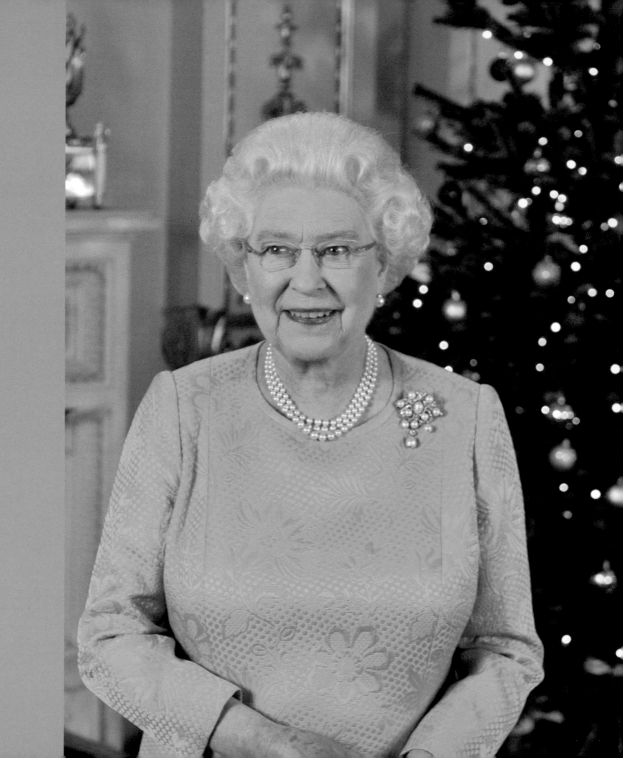

WINTER

Royal Receptions

During the course of a year, The Queen will give up to twenty receptions, usually at Buckingham Palace, for groups of several hundred guests from particular areas of British life, such as industry, commerce, education, sport, the arts and sciences. In 2009 a reception was held to celebrate the success of the British Paralympic Team at the 2008 Beijing Games.

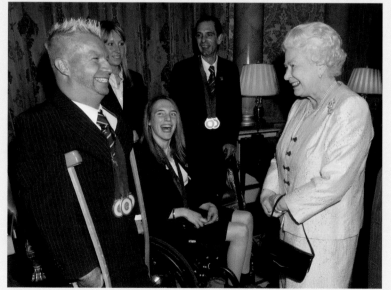

Prior to an incoming state visit, a reception may be held at Buckingham Palace for people living in the United Kingdom who are part of the visiting nation's community. In 2009 the reception that preceeded the Indian state visit included a performance in the Ballroom by a London-based dance company.

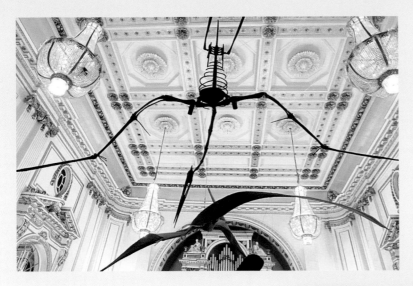

The Science Reception in 2006 was aimed at promoting interest in the sciences among young people. Eight hundred students were invited to the Palace, where the temporary displays included a giant petrosaur skeleton suspended from the ceiling of the Ballroom (above).

In March 2010 a reception for the British fashion industry was held at the Palace (right). This benefited from a display staged by curators from the fashion department of the Victoria & Albert Museum, of work by young designers.

Royal Receptions

The Queen's Award for Enterprise is bestowed by The Queen on companies and individuals who achieve particular success in the realms of international trade, innovation and sustainable development.

Recipients of the award are recommended to Her Majesty by the Prime Minister and an advisory panel made up of representatives from the government, industry, commerce and trade unions. The winners are announced each year on The Queen's actual birthday in April, and invited to a reception at Buckingham Palace.

Some receptions allow The Queen to acknowledge the work of certain groups. In May 2010 a special reception was held at Buckingham Palace to thank the Lord-Lieutenants for their efforts and work on behalf of The Queen (right).

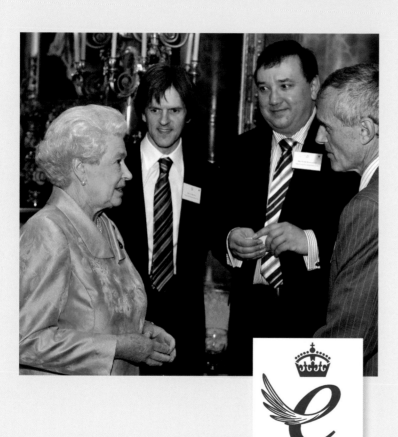

THE QUEEN'S AWARDS
FOR ENTERPRISE
2010

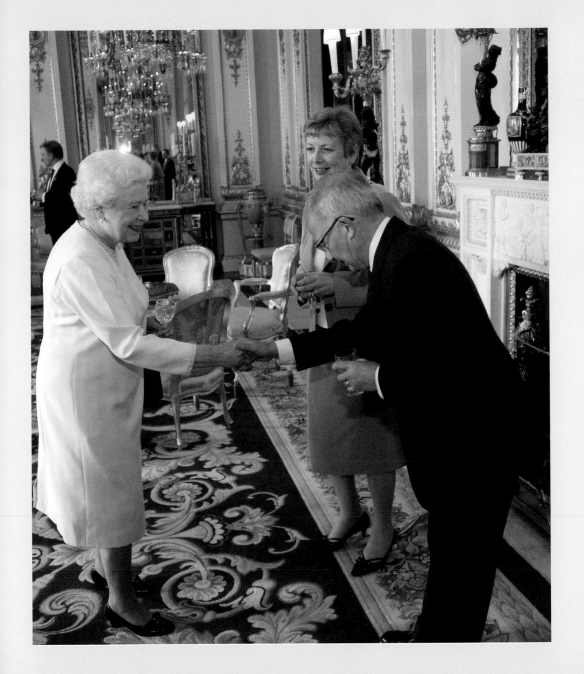

In late November the Royal Film Performance takes place, raising funds for the Cinema and Television Benevolent Fund. The first event of this kind was in 1934, when the then Prince of Wales became the first royal patron of the Fund. The event provides leading figures from the film world, such as Daniel Craig (below), with an opportunity to meet The Queen.

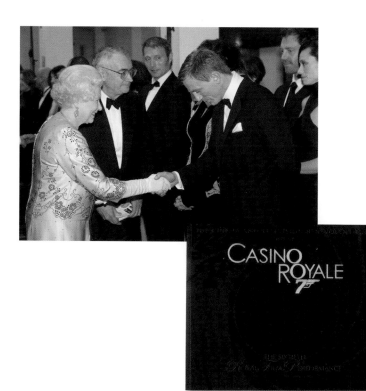

Royal Film Performances during The Queen's reign have included:

1954	Beau Brummell
1962	West Side Story
1966	Born Free
1968	Romeo and Juliet
1969	The Prime of Miss Jean Brodie
1971	Love Story
1974	The Three Musketeers
1975	Funny Lady
1976	The Slipper and the Rose
1978	Close Encounters of the Third Kind
1980	Kramer vs Kramer
1981	Chariots of Fire
1985	A Passage to India
1988	Empire of the Sun
1997	Titanic
1999	Stars Wars Episode I
2002	Die Another Day
2005	The Chronicles of Narnia
2006	Casino Royale
2008	A Bunch of Amateurs
2009	The Lovely Bones

Norman Hartnell designed
this dress, which was worn by
The Queen to the Royal Film
Performance of *West Side Story*
in 1962. Her Majesty, shown here
meeting the Italian actress Claudia
Cardinale, also wore the
Grand Duchess Vladimir Tiara
decorated with pearls.

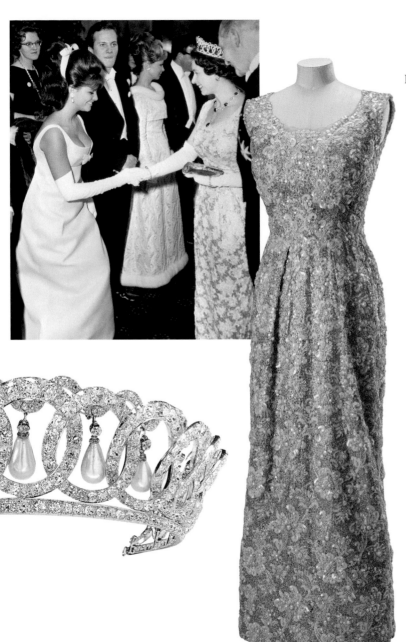

The Royal Variety Performance dates from
1912, when King George V accepted an
invitation to attend a performance to raise money
for the Entertainment Artistes' Benevolent Fund.
Since then the occasion has become a fixture of
the royal calendar in early December. The event
affords many stars of music and the stage
the opportunity to perform for The Queen.

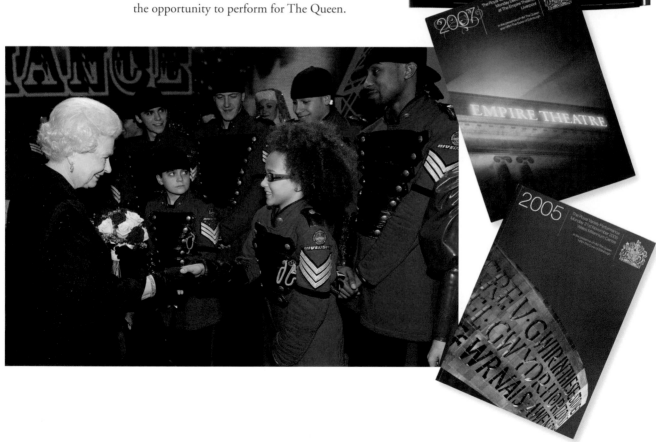

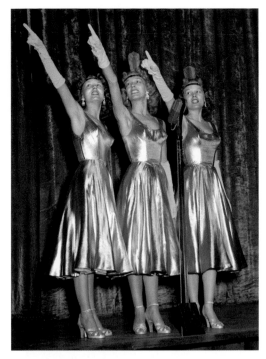

In 1952, the first year of The Queen's reign, the Royal Variety Performance included acts such as the Beverley Sisters (left), Norman Wisdom and Tony Hancock. The Beatles (below left) appeared in 1963, and in 1966, when England won the World Cup, the entire England football team appeared on stage.

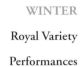

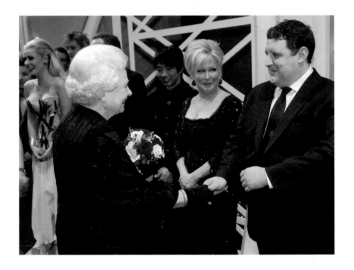

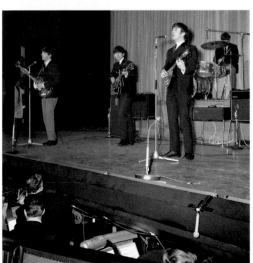

In 2009 the performance took place in Blackpool, and was hosted by the comedian Peter Kay (above) with acts that included Lady Gaga, Diversity (far left), Whoopi Goldberg and the cast of *Sister Act*, Michael Bublé, Alexandra Burke, Miley Cyrus and Katherine Jenkins.

Audiences

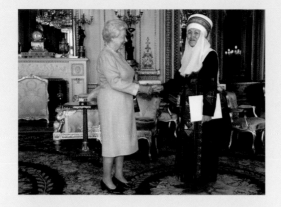

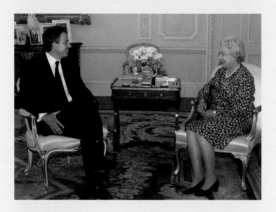

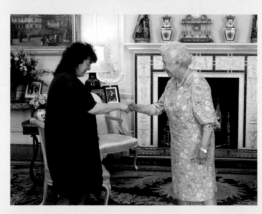

The Queen gives numerous audiences throughout the year, each one lasting about twenty minutes. These are usually private meetings, although sometimes newly appointed high commissioners and ambassadors are accompanied by members of their families and staff. Customarily the Prime Minister has a weekly audience with The Queen, and the Chancellor of the Exchequer attends before announcing a new Budget. When a foreign Head of State is visiting London without the full ceremony of a state visit, The Queen will often grant an audience. Such meetings are also granted to newly-appointed bishops and judges, the Chief of Defence Staff and the Poet Laureate, as well as the commanding officers of regiments, who attend prior to taking up their new command.

A high proportion of audiences are granted to ambassadors or Commonwealth high commissioners assuming or relinquishing their positions in London, who are presented to The Queen by the Marshal of the Diplomatic Corps. Ambassadors, who often attend in national dress, present to The Queen their Letters of Credence, which signify formal accreditation from their country's Head of State – a custom that has its origins in the nineteenth century. After an audience the ambassador signs The Queen's Visitor Book.

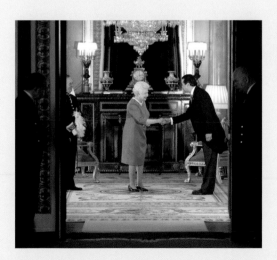

The painting below shows the reception of the Moroccan Ambassador by King Edward VII at St James's Palace in 1902.

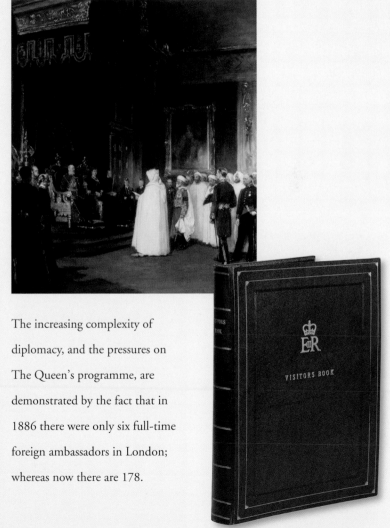

The increasing complexity of diplomacy, and the pressures on The Queen's programme, are demonstrated by the fact that in 1886 there were only six full-time foreign ambassadors in London; whereas now there are 178.

The tradition of the Christmas broadcast began in 1932. King George V, The Queen's grandfather, opened the first radio broadcast with the words 'I speak now from my home and from my heart to you all'. This encapsulates the essence of the Christmas speech, which remains an integral part of Christmas Day for many in the United Kingdom and the Commonwealth. The Queen's first Christmas messages were also broadcast by radio.

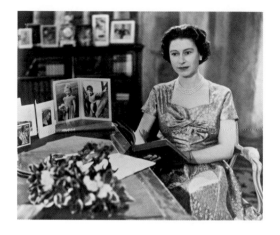

For her first transmission (left), in 1952, Her Majesty used the same desk and chair at Sandringham as those used by her grandfather in 1932. Her first televised message (above) was made in 1957. In the days before it was possible to pre-record television, the message went out live.

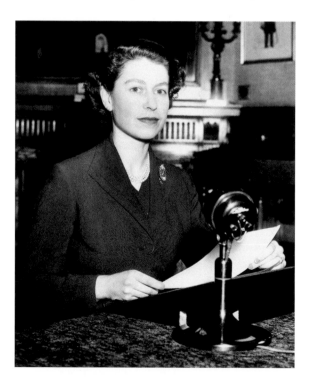

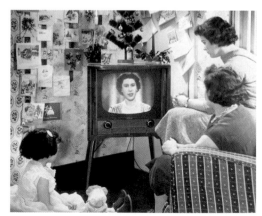

Televised broadcasts allowed a new insight for viewers, enabling them to see The Queen at home for the first time. Since 1960 it has been possible for the message to be pre-recorded in mid-December, allowing tapes of the speech to be transported around the Commonwealth in time for Christmas Day. It has become a Christmas tradition at the recording of the broadcast for the microphone to be decorated with holly. Now modern technology has been fully harnessed, the speech may be watched on the internet at any time, although despite this it has remained firmly fixed in the Christmas Day schedule at 3pm.

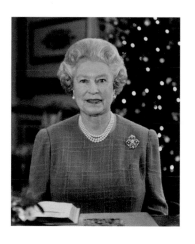

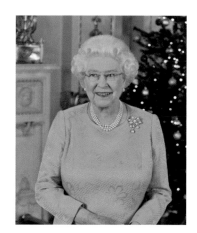

WINTER

The Christmas

Broadcast

The broadcast is a rare opportunity for The Queen to express concerns and opinions of her own, in relation to both the United Kingdom and the Commonwealth. It often reflects events of the previous year, and is intended to encourage and reassure, to congratulate and celebrate. Planning begins early in the year, so that appropriate occasions can be filmed for inclusion, such as this scene (top) from the 1978 broadcast, showing The Queen with her daughter and grandson, and Her Majesty's visit to a school in 2006 (below).

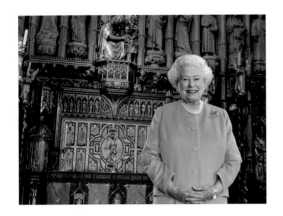

In 2002, the Golden Jubilee year, The Queen spoke of her grief at the deaths of her mother, Queen Elizabeth The Queen Mother, and her sister, Princess Margaret, and thanked the public for their support:

At such a difficult time this gave me great comfort and inspiration as I faced up both to my own personal loss and to the busy Jubilee summer ahead.

She also said that the Jubilee celebrations were:

... joyous occasions that also seemed to evoke something more lasting and profound – a sense of belonging and pride in country, town, or community.

In 2003, with conflicts in the Middle East, The Queen chose to make her broadcast from the Household Cavalry Barracks in Windsor, saying:

I want to draw attention to the many servicemen and women who are stationed far from home this Christmas. I am thinking about their wives and children, and about their parents and friends.

Christmas

It is traditional for the Royal Family to spend Christmas at Sandringham House in Norfolk, one of The Queen's private residences. The estate was bought in 1862 for Albert Edward, Prince of Wales, Queen Victoria's eldest son. As King Edward VII he continued to use the house, and it has remained popular with the Royal Family ever since.

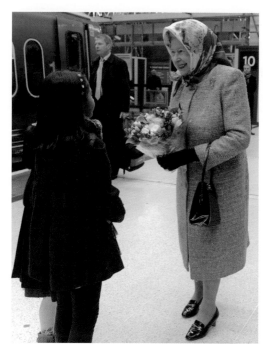

The Queen first stayed at Sandringham in 1926 when she was only eight months old, visiting her grandparents, King George V and Queen Mary. Her Majesty now usually travels there by train.

From 1964 to 1988, the Royal Family celebrated
Christmas at Windsor Castle, but Sandringham
has now become the preferred venue. The family
still celebrate in the way Queen Victoria and
Prince Albert did, exchanging their gifts on
Christmas Eve. The painting on the right gives
a taste of the Victorian Christmas at Windsor
Castle in 1851, with a beautifully decorated
Christmas tree of the kind that Prince Albert
popularised in Britain.

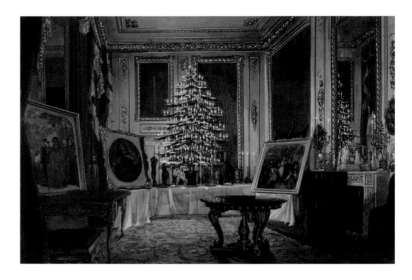

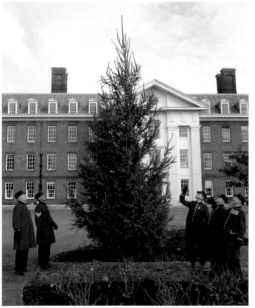

Every year The Queen presents a Christmas tree
to several important institutions including
Westminster Abbey, St Paul's Cathedral, St Giles's
Cathedral in Edinburgh, Wellington Barracks
in central London, and the Royal Hospital in
Chelsea (left).

Each year at Christmas The Queen receives a spray of Holy thorn from the garden of Glastonbury Abbey. An ancient legend claims that the thorn will always blossom on Christmas Day, and a spray from this tree has been sent to the sovereign since the reign of James I. The flowers last for several weeks and it is kept on Her Majesty's desk at Sandringham during this time. In 1999 the thorn was presented to Her Majesty in person (right).

On the morning of Christmas Day The Queen attends Mattins at the church of St Mary Magdalene close to Sandringham House, with other members of the Royal Family.

On 6 January, whilst The Queen is still at Sandringham, a special Holy Communion service in the Chapel Royal at St James's Palace marks the Feast of the Epiphany and the end of the Christmas season. Epiphany is the celebration of the presentation of gifts by the Magi (or three kings) to the infant Jesus. Two of The Queen's Gentlemen Ushers present offerings of gold, frankincense and myrrh – known as 'The Queen's Gifts' – on two King George IV gold patens. This service has a long history, dating back to the eleventh century. The gold is presented in the form of twenty-five gold sovereigns. Some of these are from the reign of Queen Victoria, when they were introduced at the suggestion of Prince Albert. This ceremony anticipates the beginning of an entirely new Royal year.

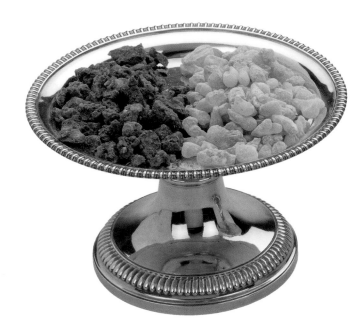
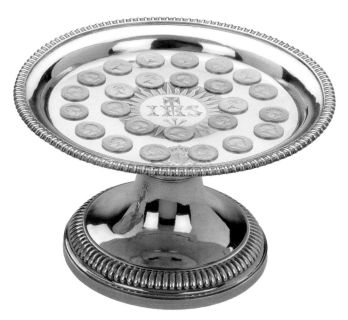

Illustrations

Unless otherwise stated, all illustrations are The Royal Collection © 2010, HM Queen Elizabeth II. Royal Collection Enterprises are grateful for permission to reproduce those items listed below for which copyright is not held by the Royal Collection.

All photographs listed as 'IJP' are © Ian Jones Photography

All photographs listed as 'PA' are © Press Association

Front endpaper
• Garden party invitations

Back endpaper
• The Queen's entry in the modern Garter Book, 2007 (RCIN 1102204)

Half title
• *Buckingham Palace during Trooping the Colour, 2006*: IJP

Frontispiece
• *The Queen at Berwick-upon-Tweed, 2009*: IJP

Title page
• The Imperial State Crown (front view; RCIN 31701)

Opposite contents page
• *The Red Arrows fly-past during Trooping the Colour, 2009*: IJP

Imprint page
• *The Queen's luggage*: PA

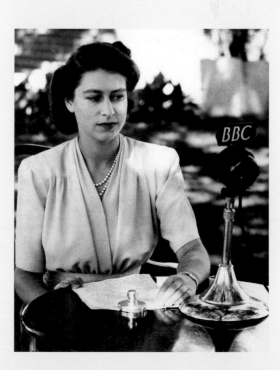

Illustrations

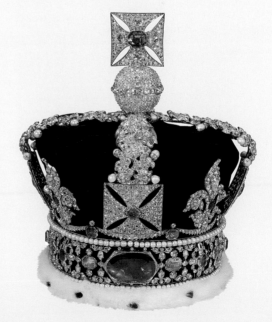

Illustrations

Illustrations

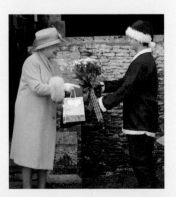